Denver
impressions

FARCOUNTRY
PRESS

photography by
Steve Mohlenkamp

RIGHT: Located on the fifteenth step of the white granite Colorado State Capitol, this medallion marks the exact elevation of 5,280 feet—which earned Denver its nickname as the "Mile High City." LAURIE MOHLENKAMP

FAR RIGHT: The Denver City Park features many fountains, statues, and formal gardens.

TITLE PAGE: A bolt of lightning arcs over the city near the Millenium Bridge, a pedestrian walkway that rises 145 feet above the South Platte River.

FRONT COVER: Denver's unique skyline against a characteristically colorful sunset.

BACK COVER: The gilded dome of the Colorado State Capitol.

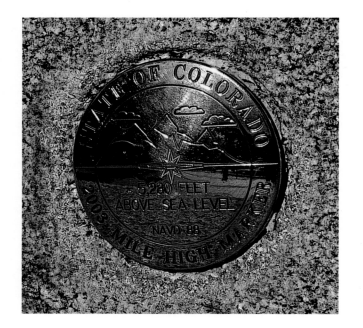

ISBN 13: 978-1-56037-348-3
ISBN 10: 1-56037-348-2
Photography © 2006 by Steve Mohlenkamp
© 2006 Farcountry Press

For more information about our books write Farcountry Press, P.O. Box 5630, Helena, MT 59604; call (800) 821-3874; or visit www.farcountrypress.com.

Created, produced, and designed in the United States.
Printed in China.

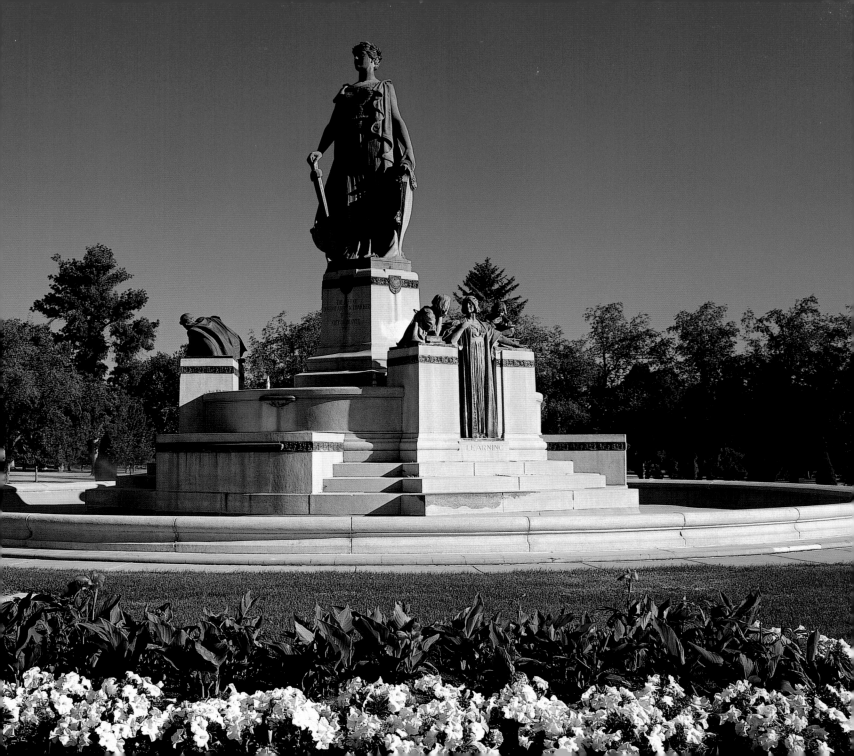

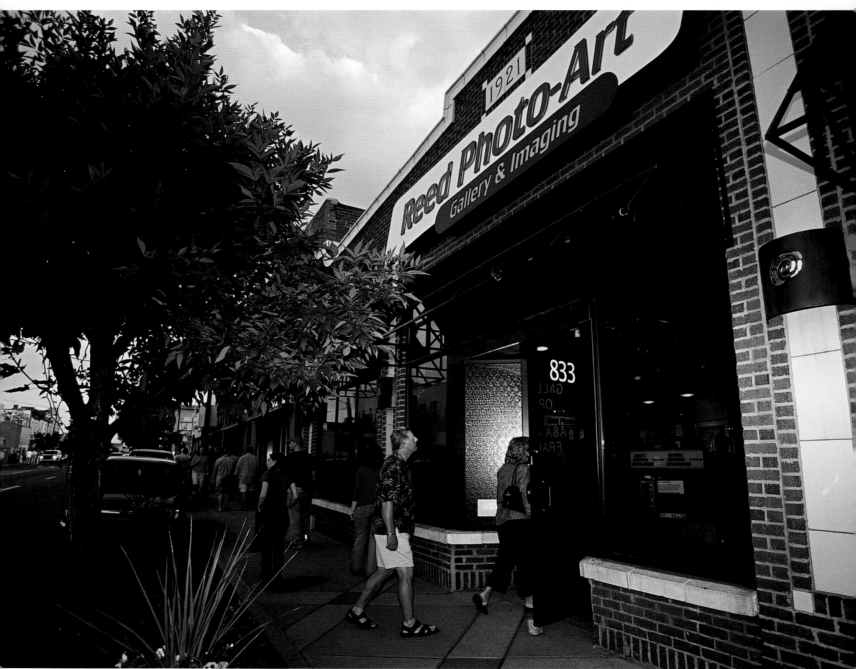

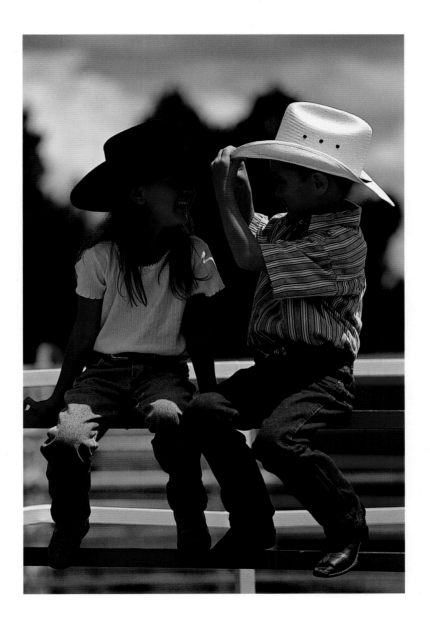

LEFT: Shaded by their cowboy hats, these kids are having the time of their lives at a local rodeo, always popular in the cowboy country of Colorado.

FAR LEFT: During the First Friday gallery walk, art patrons gather at the ever-popular Reed Photo Art Gallery, one of a number of participating businesses along Santa Fe Drive.

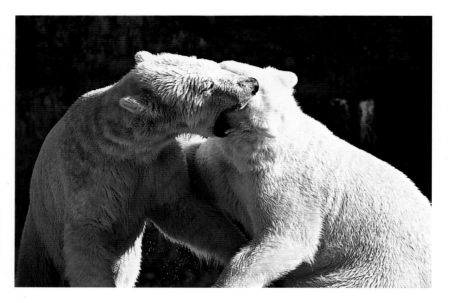

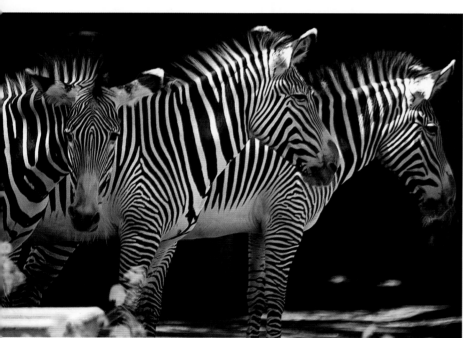

ABOVE: The polar bear cubs Klondike and Snow cavort at the Denver Zoo, which has become internationally known for its contributions to polar bear conservation.

LEFT: These zebras are some of the 750 species of animals at the Denver Zoo.

RIGHT: The *Closing Era* statue is a bronze that was commissioned for the state's entry into the 1893 World's Fair Exposition in Chicago.

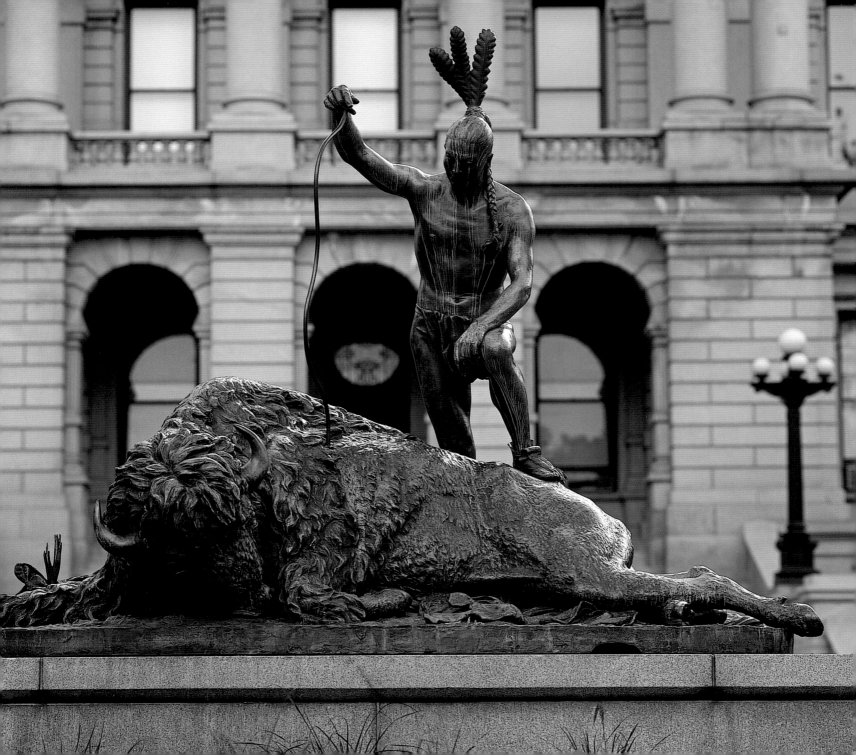

FACING PAGE: Sunset reddens the summit of the 14,110-foot Pikes Peak near Colorado Springs.

BELOW: A couple takes a romantic ride down Cherry Creek in a punt owned by Venice on the Creek, a company that offers boat rides as well as an overview of Denver history.

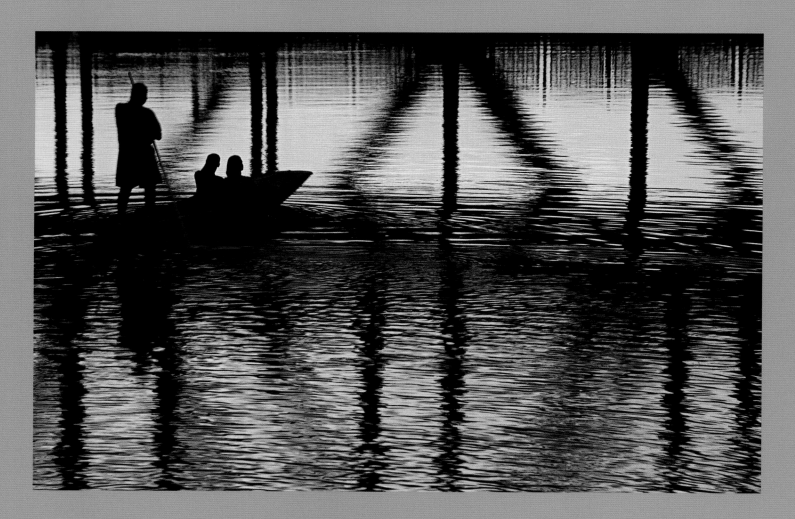

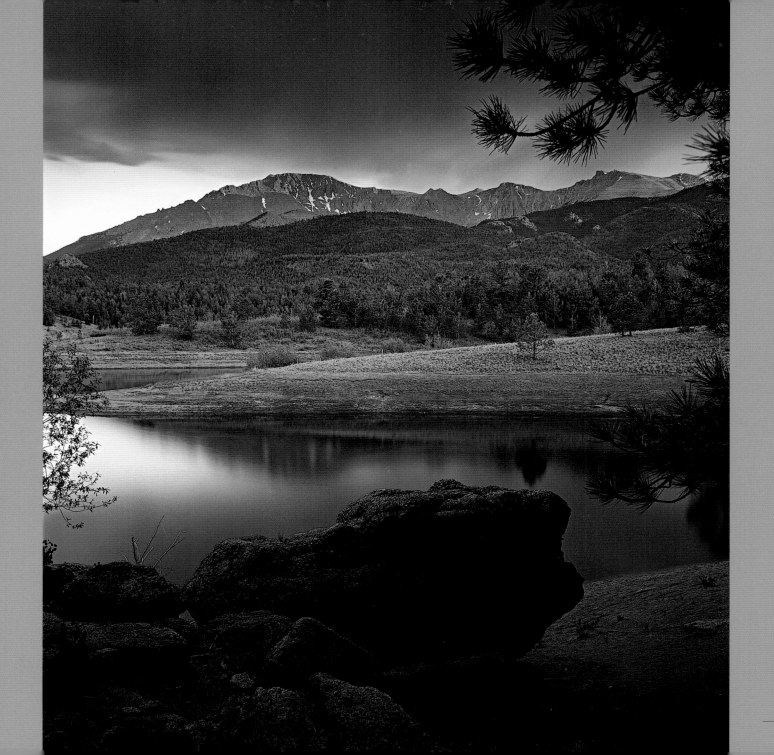

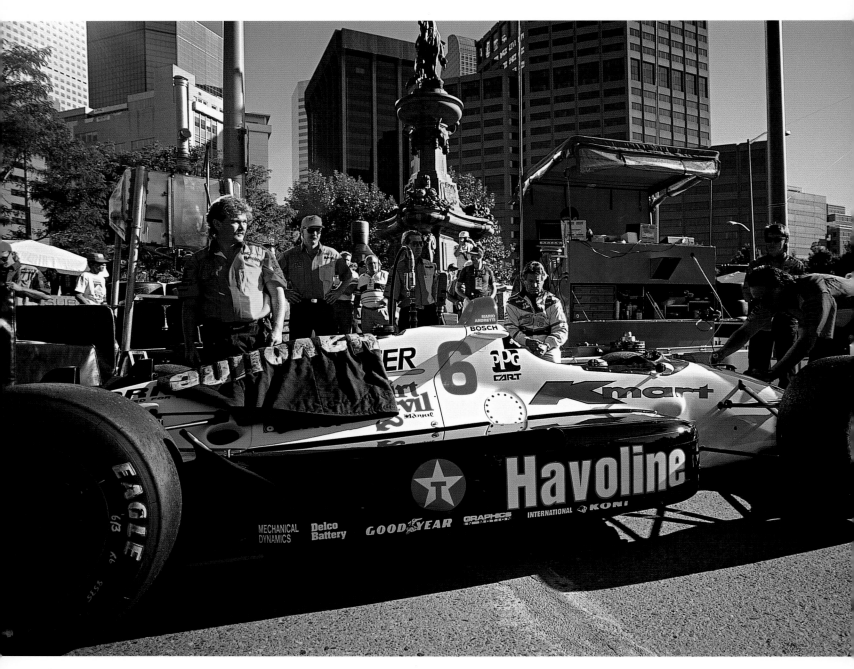

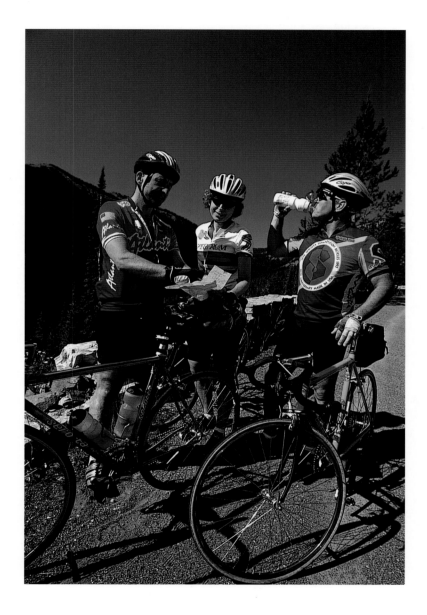

LEFT: Participants in the Ride the Rockies bicycle marathon, a six-day bicycle tour through Colorado's Rocky Mountains, stop for a breather and a quick drink of water.

FAR LEFT: Mario Andretti, one of the world's fastest racecar drivers, waits to qualify in the inaugural Denver Grand Prix held downtown.

RIGHT: Located at Eighteenth and Wynkoop Streets near Union Station, the brick Ice House Lofts building was built in 1903 and housed the Littleton Creamery and the Beatrice Foods Cold Storage Warehouse.

BELOW: The Tattered Cover is one of the largest bookstores in the country. The beloved four-story bookstore is popular with Denver residents and visitors alike.

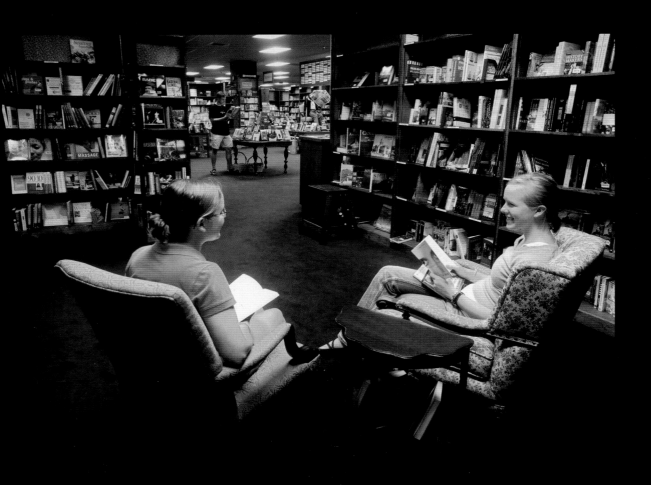

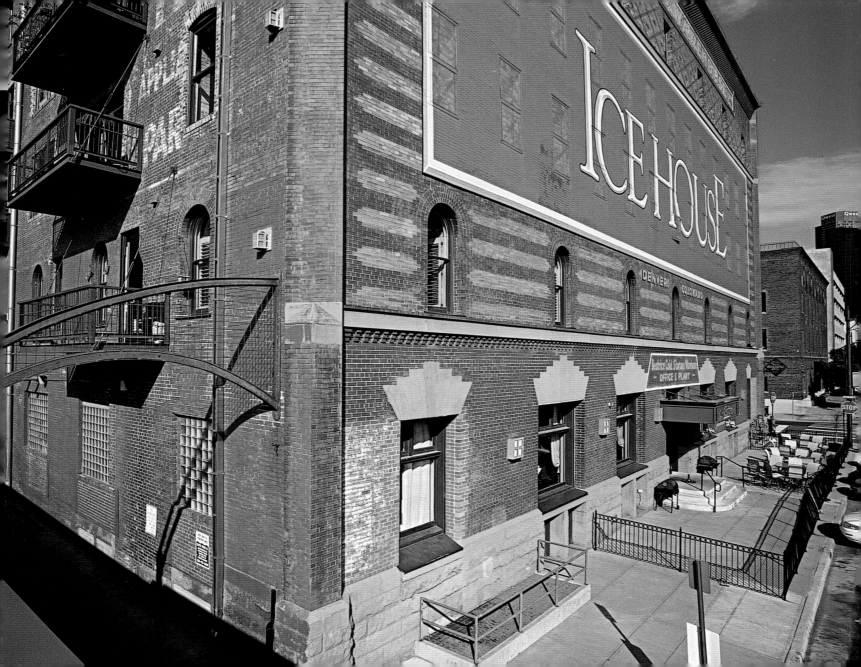

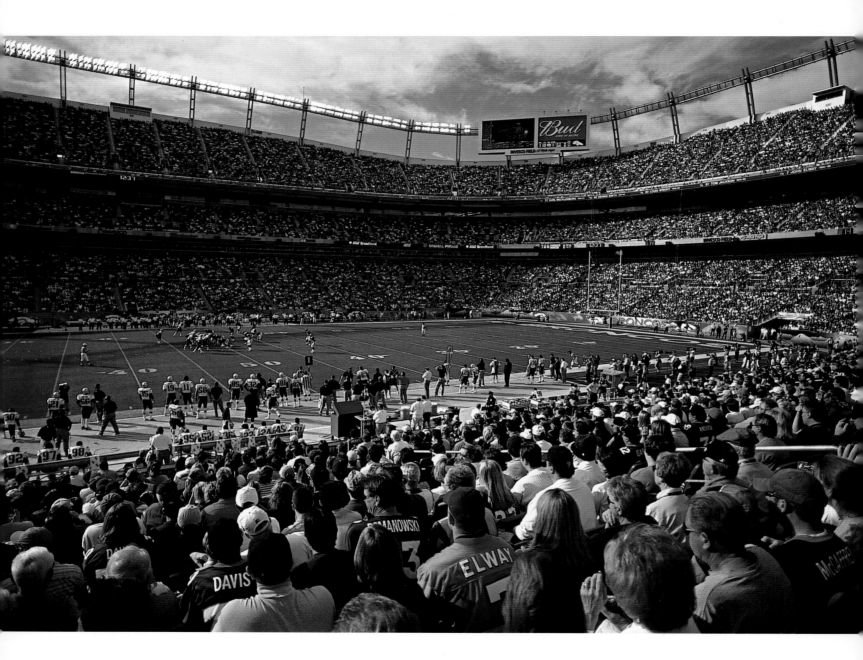

ABOVE: Denver Broncos fans have packed every game at Invesco Field
at Mile High Stadium since it was built in 1999.

RIGHT: Hall of Fame quarterback John Elway demonstrates the throwing arm that made him a Denver Bronco legend from 1983 to 1998.

BELOW: The Denver Broncos' mascot, Thunder, does a victory lap around the field every time the team scores a touchdown.

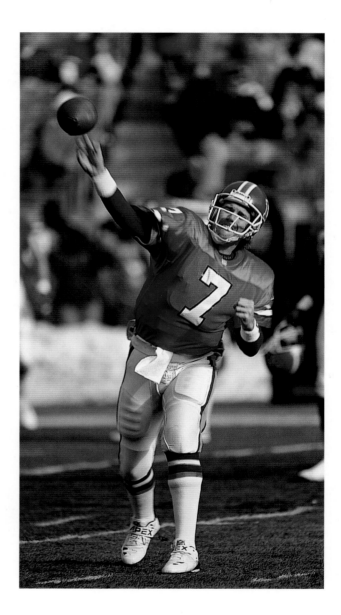

RIGHT: Although she preferred to stay at the Brown Palace in downtown Denver, Molly Brown's last home was this 1886 Victorian mansion. She was better known as the Unsinkable Molly Brown because she survived the sinking of the *Titanic*.

BELOW: The library and parlor inside the Molly Brown House Museum feature stained glass windows and ornamental wooden trim.

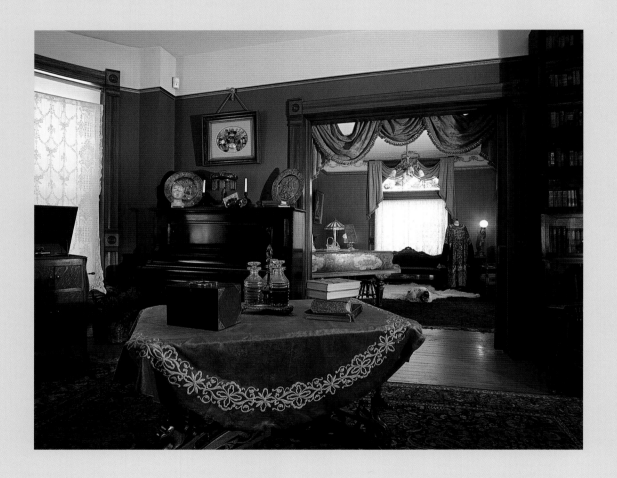

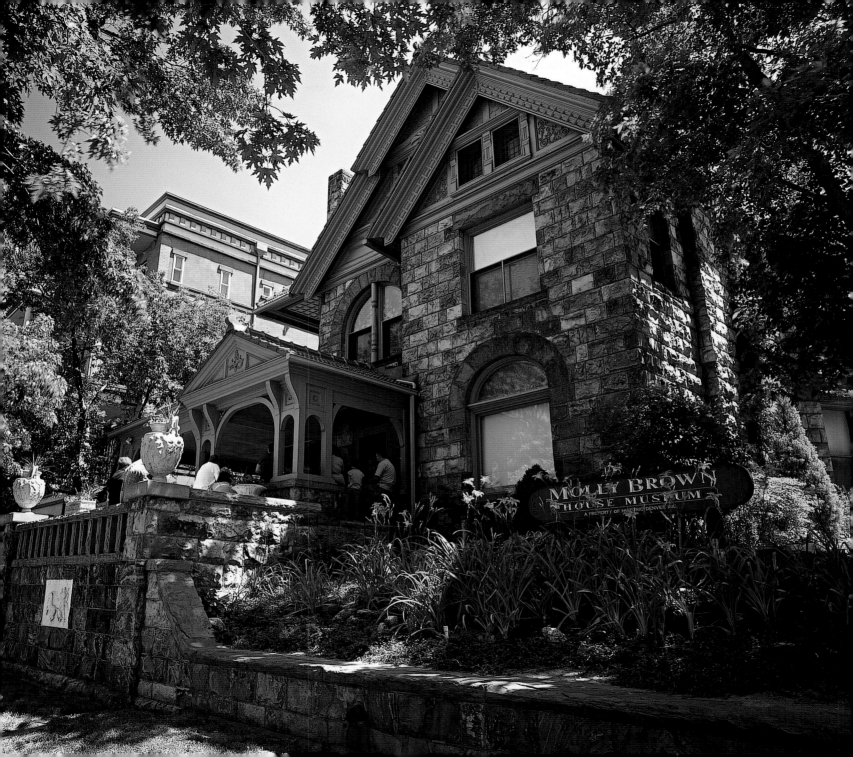

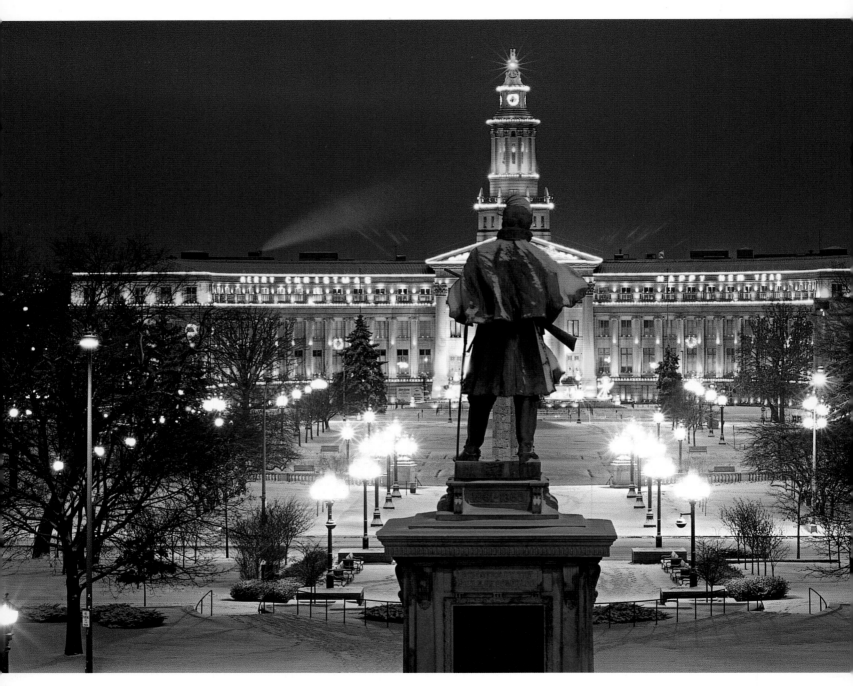

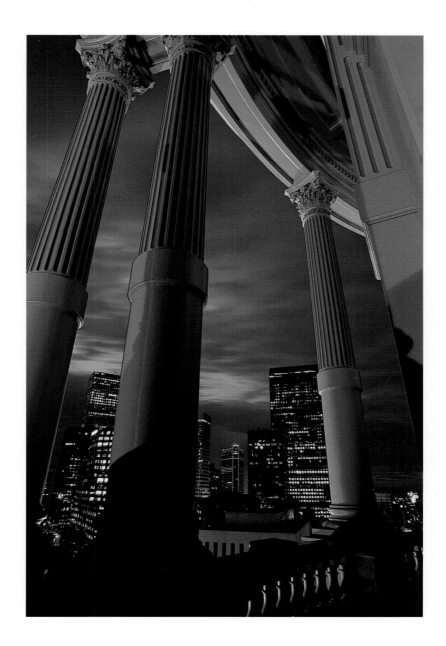

LEFT: These stately Corinthian columns support the gold-domed Colorado State Capitol, which was built in the 1890s to resemble the U.S. Capitol.

FAR LEFT: The Denver City and County building features an elaborate lighting display during the Christmas season.

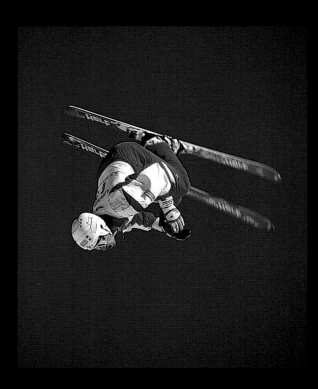

ABOVE: This freestyle skier launches himself into the sky at the World Ski Championships in nearby Breckenridge.

RIGHT: An April snow whitens the trees in Rocky Mountain National Park.

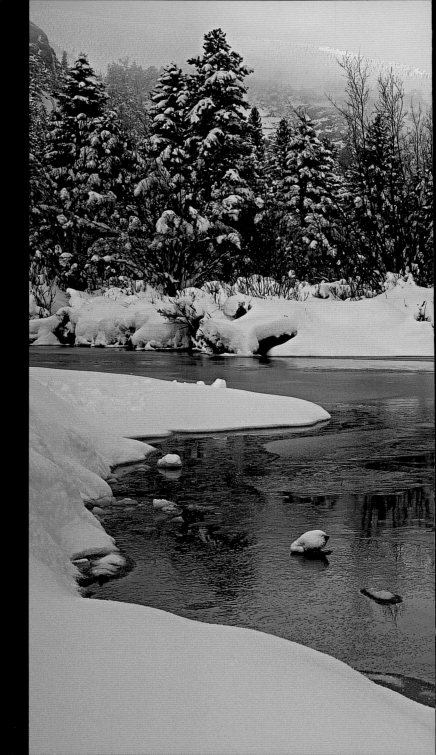

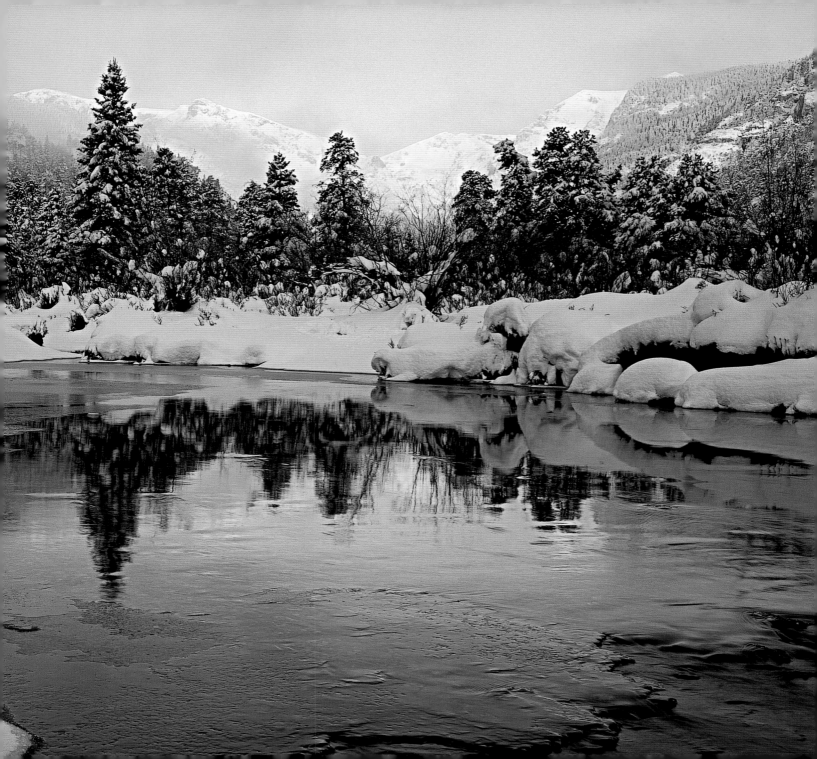

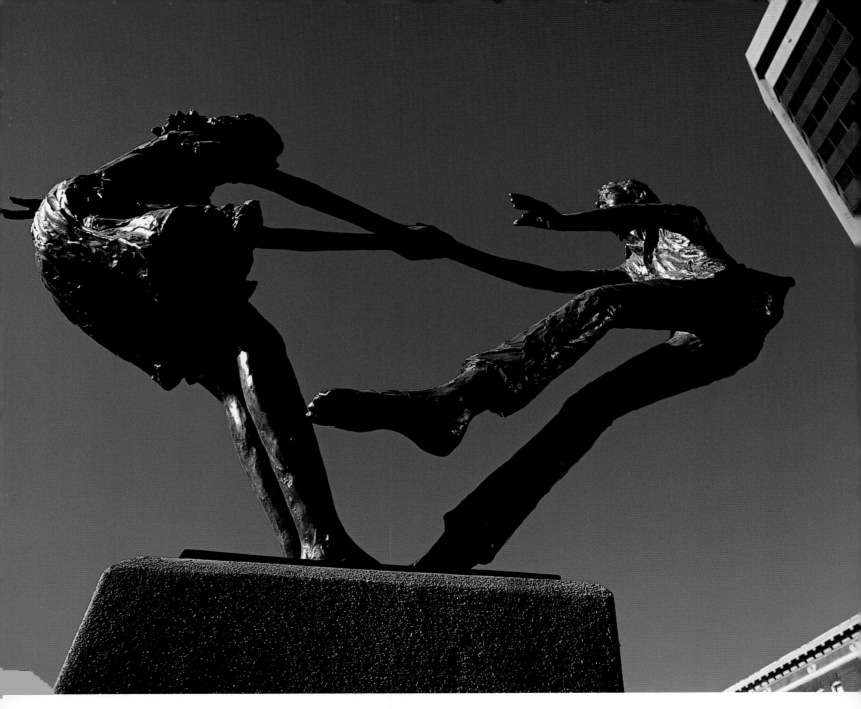

LEFT: This bronze statue of dancers "cutting a rug" is located on the Sixteenth Street Mall, a sixteen-block pedestrian mall at the core of downtown Denver.

RIGHT: A chalk art picture from the La Piazza dell'Arte festival, when Larimer Square is transformed into a street museum of chalk art pieces. LAURIE MOHLENKAMP

BELOW: An artist works diligently on his entry in the Larimer Square chalk art festival.

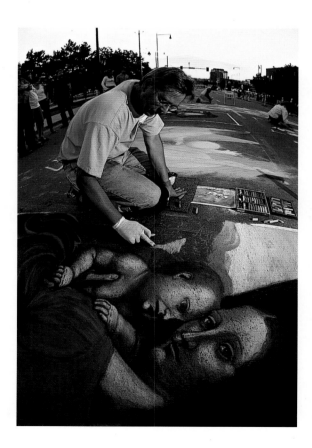

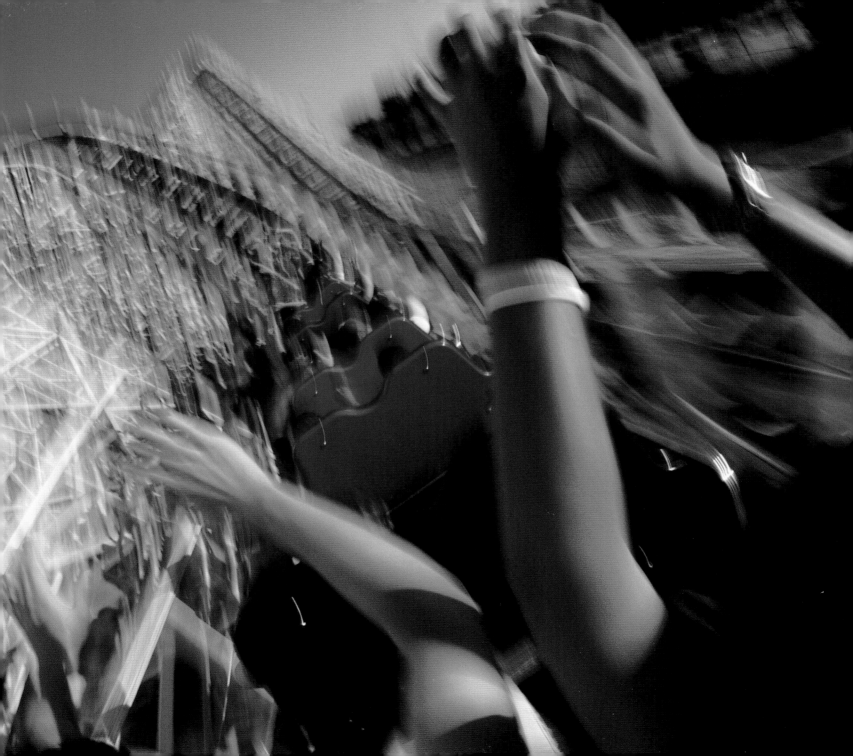

LEFT: All hands are up on this roller coaster at Six Flags Elitch Gardens, an amusement park known as Colorado's roller coaster capital.

BELOW: Visitors enjoy a carriage ride past the Colorado State Capitol.

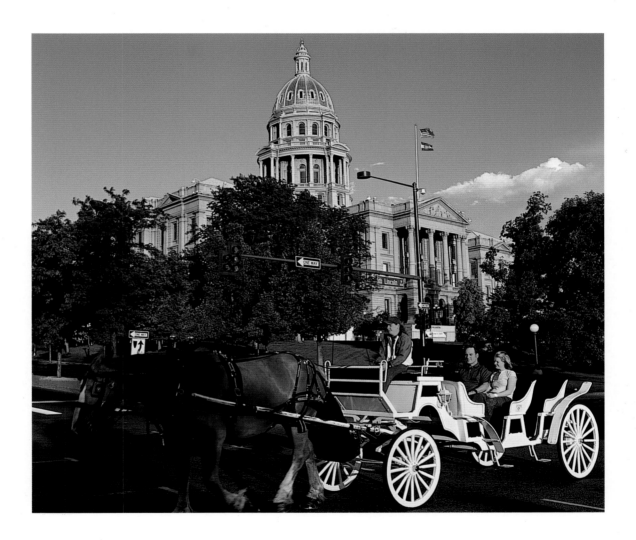

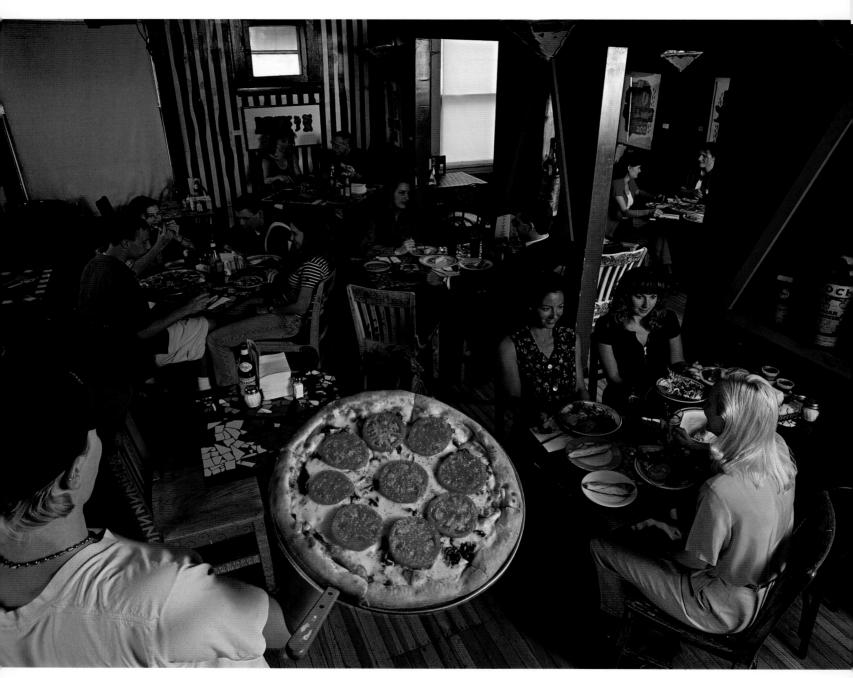

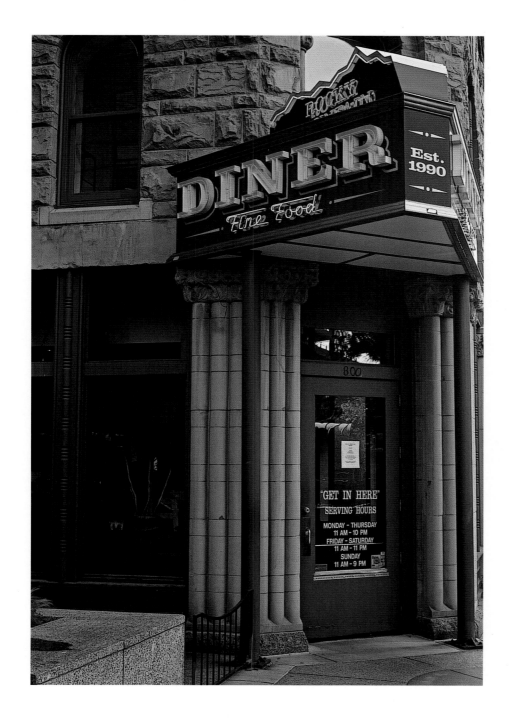

LEFT: Famous for its pan-fried chicken, buffalo meatloaf, and other unique dishes, the Rocky Mountain Diner features wooden booths and a jukebox in the historic Ghost Building at Eighteenth and Stout Streets.
LAURIE MOHLENKAMP

FAR LEFT: Pasquini's Pizzeria, which opened in 1986, is a popular spot for New York and Sicilian style pizza, as well as calzones and focaccia sandwiches.

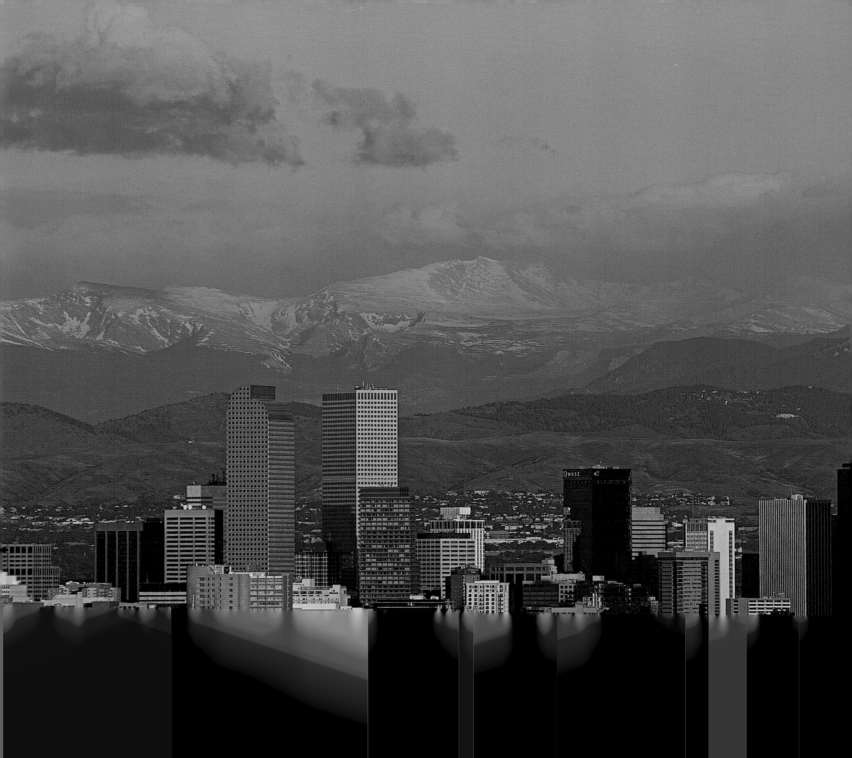

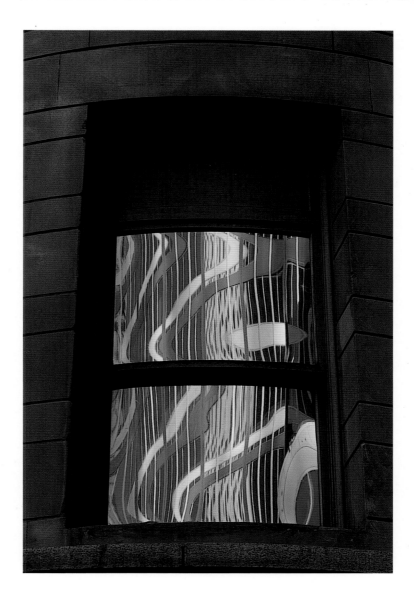

ABOVE: An abstract cityscape is reflected in the luxury Brown
Palace Hotel, which was built in 1892 and is the oldest hotel
in downtown Denver.

LEFT: The Denver skyline and the surrounding Rocky Mountains
are painted in the pinks and purples of summer sunrise.

RIGHT: As the proprietor of the Denver Folklore Center for acoustic instruments, Harry Tuft has met many folk singers early in their careers.

FACING PAGE: Brian Miller demonstrates his world-class skill at the skateboard arena at Riverside Park, which features five skateboard ramps and is the site for the Riverside Skate School.

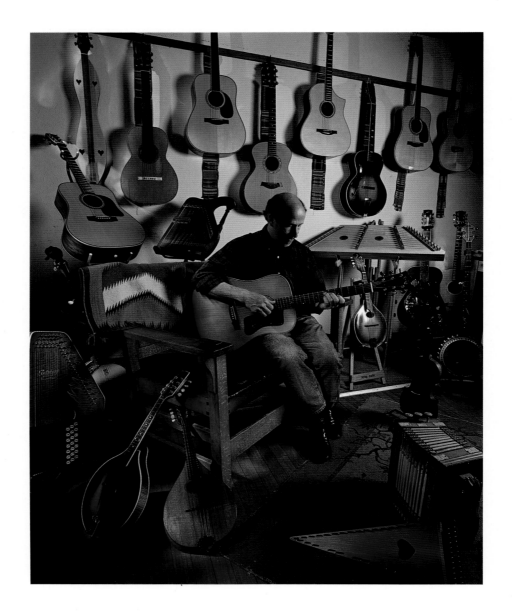

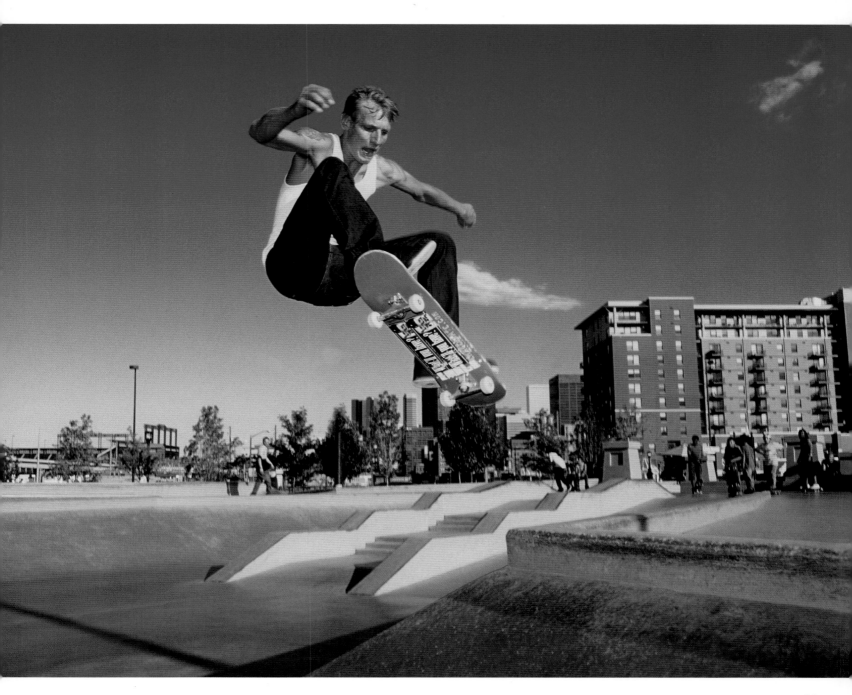

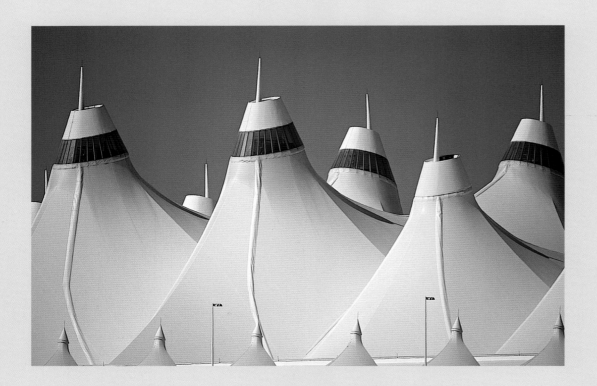

ABOVE: The distinctive roof of the Jeppessen Terminal at the Denver International Airport is made of Teflon-coated fiberglass. LAURIE MOHLENKAMP

RIGHT: Light can penetrate the 900- by 210-foot roof fabric of the Jeppessen Terminal atrium, but the canopy does not store or conduct heat.

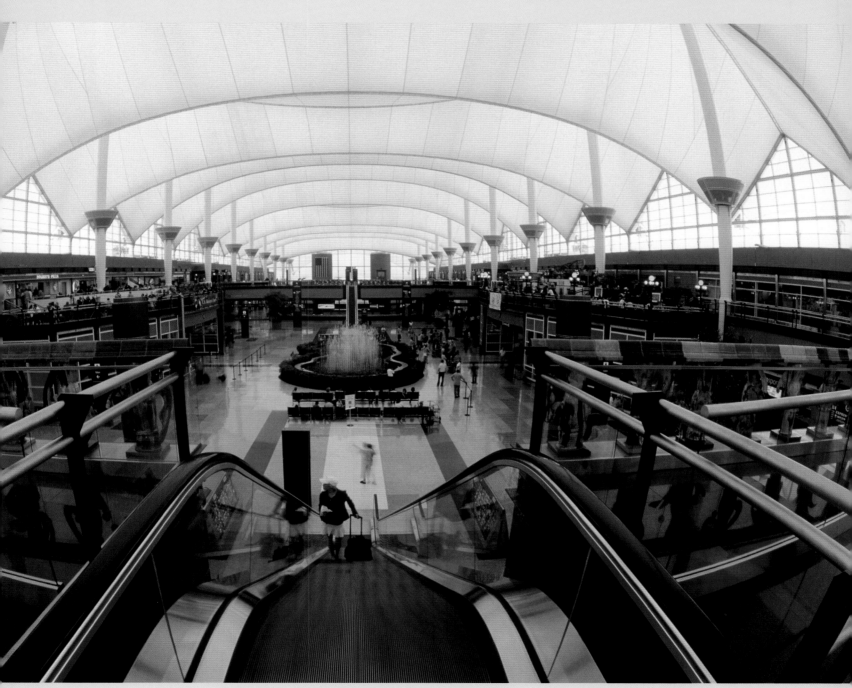

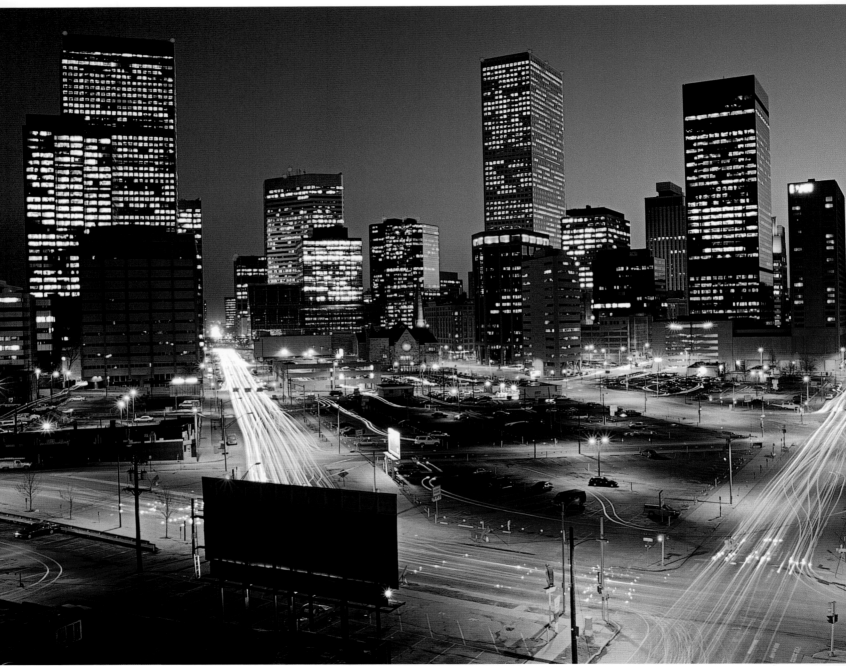

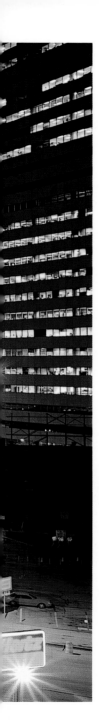

LEFT: The blur of rush hour illuminates downtown Denver at dusk.

BELOW: Some of the many varieties of beer produced by the Adolf Coors Brewing Company in Golden are brewed in these huge kettles.

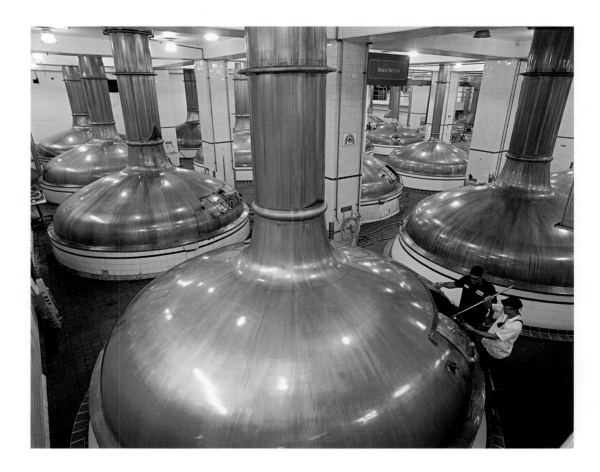

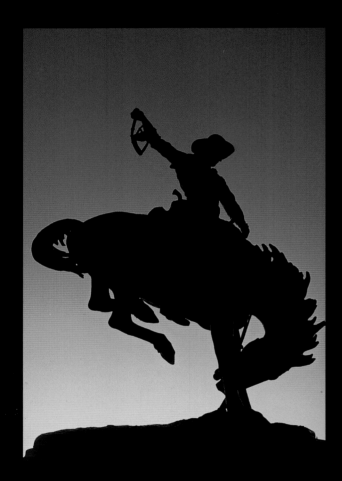

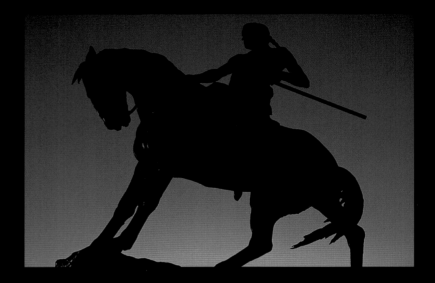

ABOVE: This 1922 bronze sculpture entitled *On the Warpath* was created by sculptor Alexander Phimister Proctor and is located in the Civic Center Park.

LEFT: This bronze *Bronco Buster* was also sculpted by Proctor and given to the city in 1920. It is also located in Civic Center Park.

RIGHT: Downtown is awash in pink with the early morning sunrise.

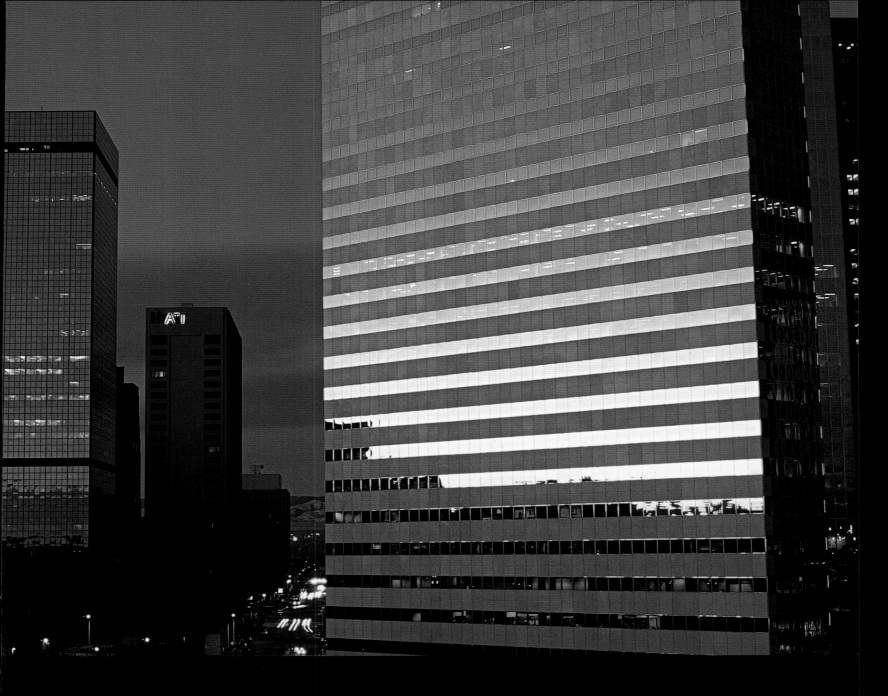

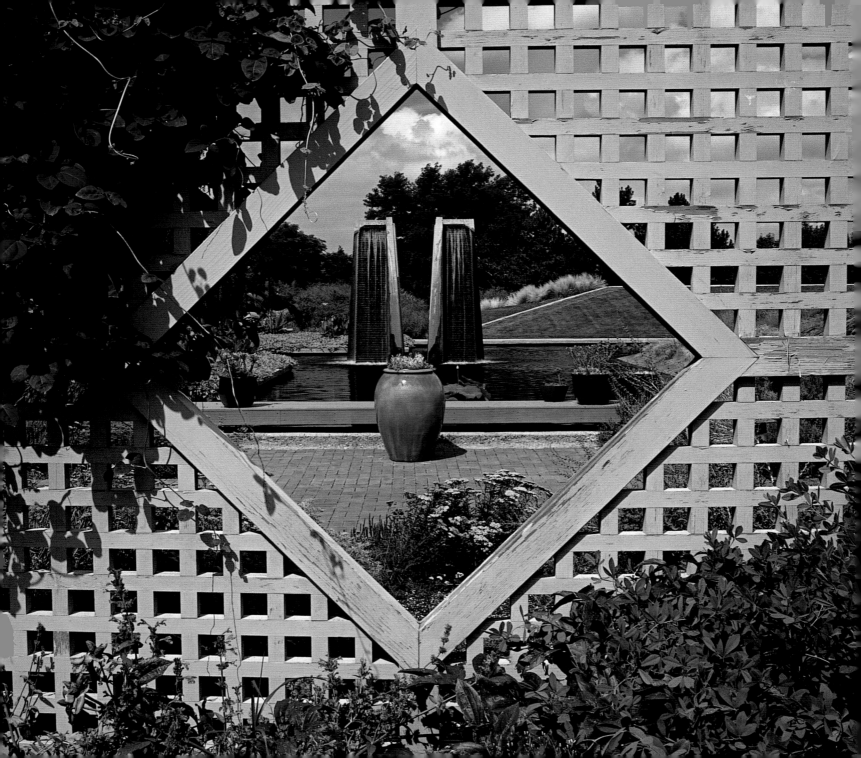

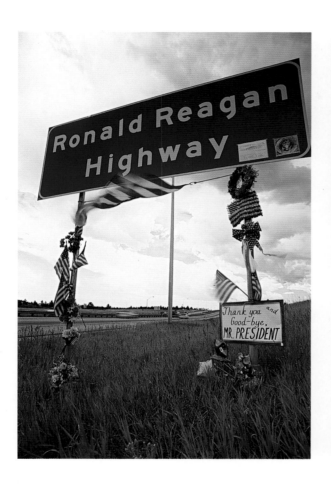

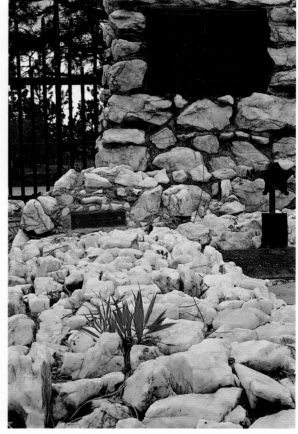

ABOVE: Interstate 25 between Denver and Colorado Springs has been dedicated as the Ronald Reagan Highway. LAURIE MOHLENKAMP

LEFT: An image of balance and harmony at the twenty-three-acre Denver Botanic Gardens.
LAURIE MOHLENKAMP

ABOVE: Buffalo Bill Cody, buffalo soldier and creator of the Wild West Shows, was buried in this grave on Lookout Mountain in 1917. LAURIE MOHLENKAMP

RIGHT: The Byron White United State Courthouse, a neo-classical structure built between 1910 and 1916, houses the Court of Appeals for the Tenth Circuit and is named after the Coloradan that served on the U.S. Supreme Court.

FAR RIGHT: The state-of-the-art Colorado Convention Center features nearly 800,000 square feet of space and hosts events ranging from concerts to festivals to large conventions.

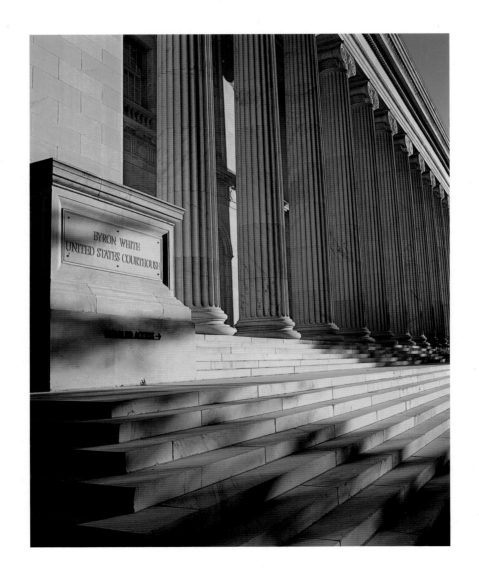

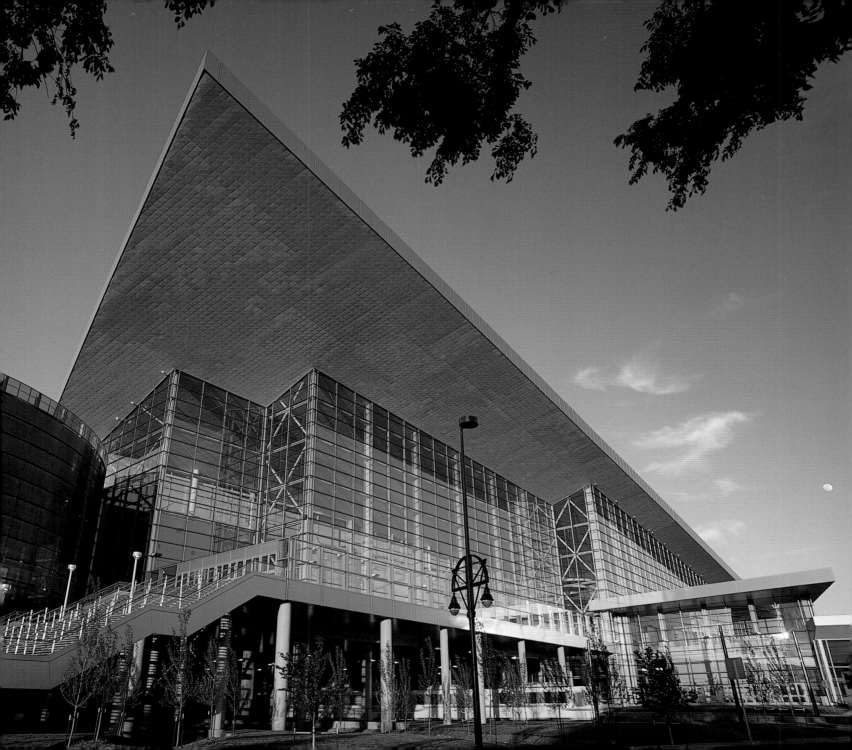

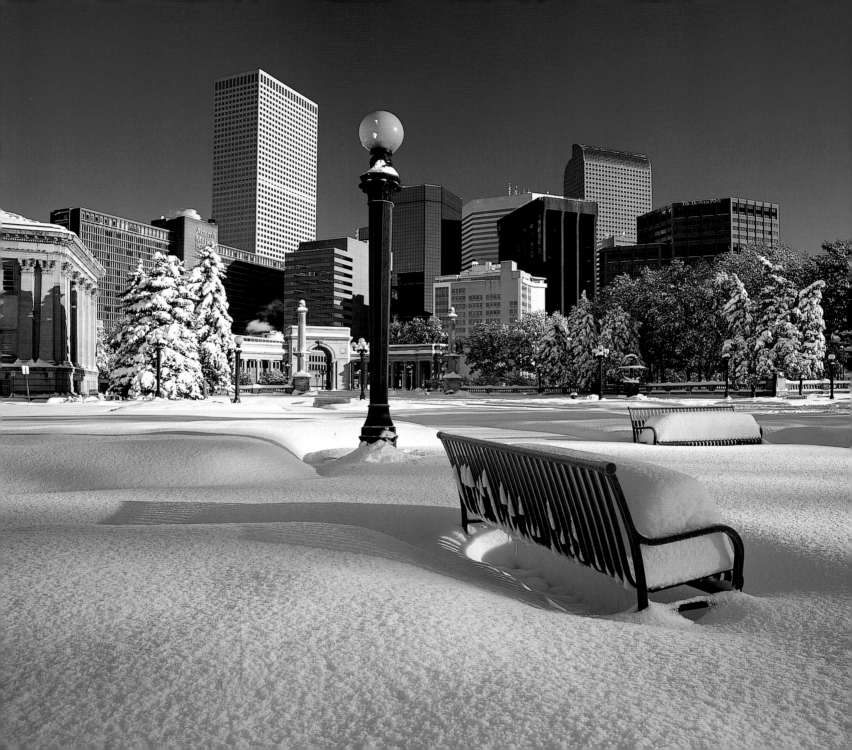

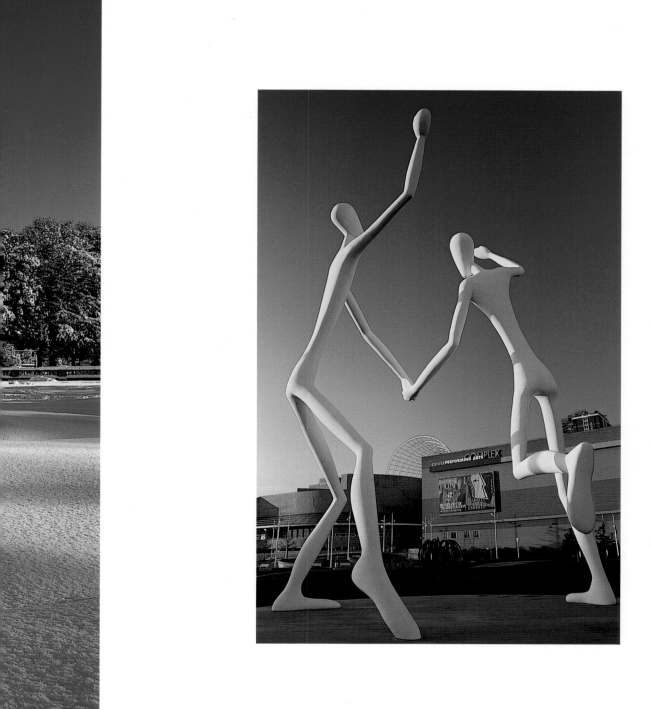

LEFT: This sculpture of dancers frolicking is located in front of the Denver Center for the Performing Arts, a complex with eight theaters in downtown Denver.
LAURIE MOHLENKAMP

FAR LEFT: An early October snow blankets the sidewalks and benches in downtown Denver.

43

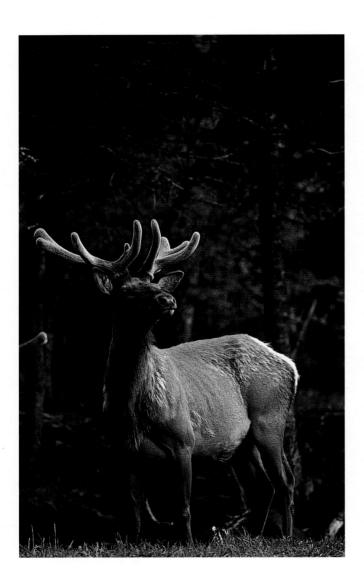

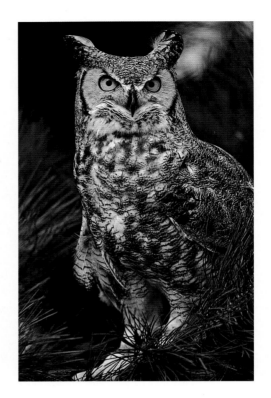

ABOVE: A great horned owl offers a pensive gaze from its perch at the Rocky Mountain Raptor Center in Fort Collins, a rehabilitation center for injured birds of prey.

LEFT: An elk in velvet pauses to survey its surroundings in Rocky Mountain National Park, which abounds with wildlife.

RIGHT: In the distance is 14,259-foot Longs Peak, northwest of Denver, as photographed from the notch on Trail Ridge Road, a forty-eight-mile National Scenic Byway and the highest continuously paved road in America.

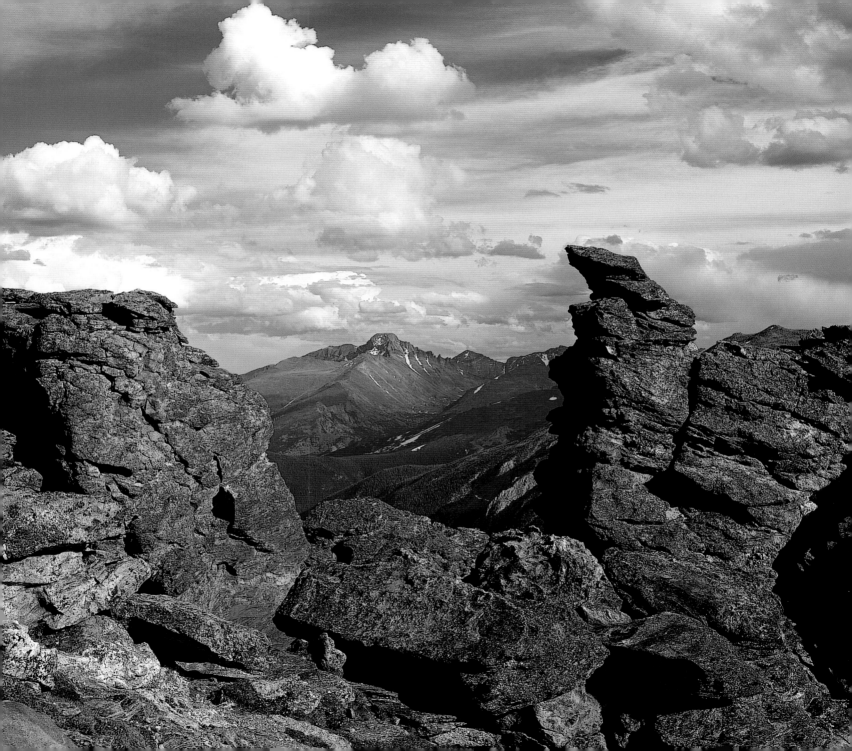

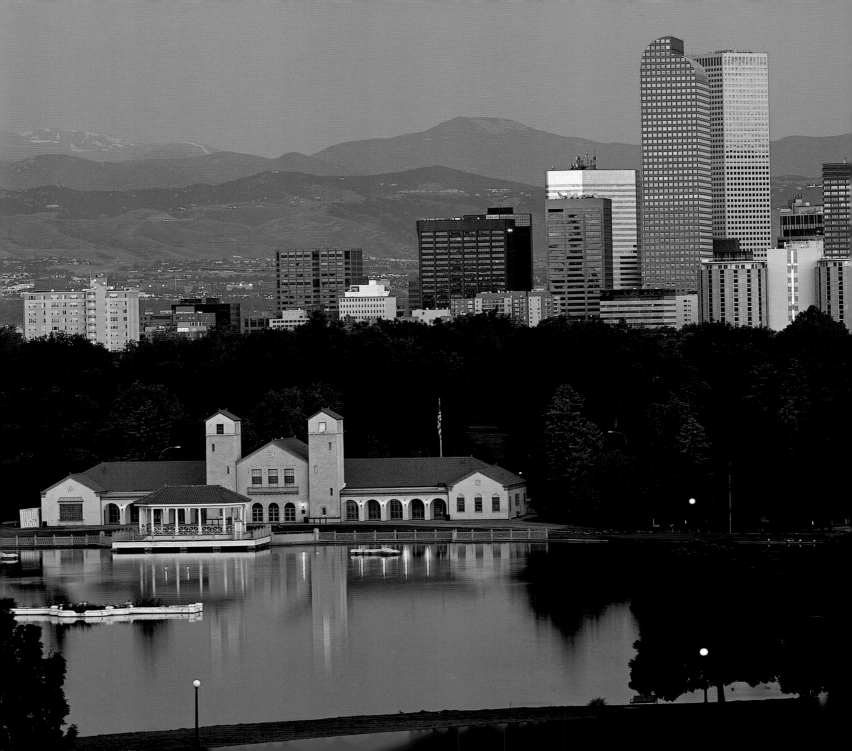

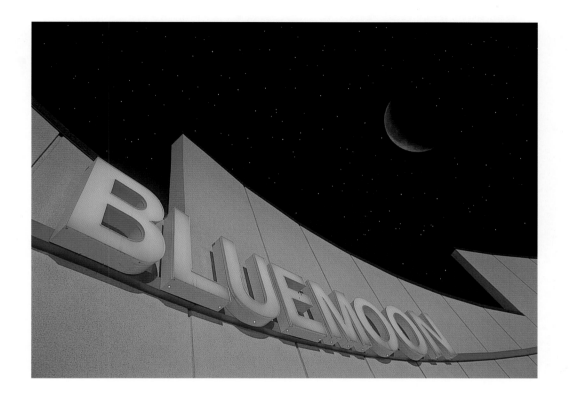

ABOVE: The marquee of the Blue Moon flower shop on Sixth Avenue lies in the shadow of the real thing.

LEFT: The boathouse at the Denver City Park features two manmade lakes, with the downtown skyline and the jagged Rocky Mountains in the background.

RIGHT: A weary cowboy catnaps in the doorway of a Western store while waiting for a bus on South Broadway Street.

BELOW: Two women sip coffee at the Gypsy House on Marion Street.

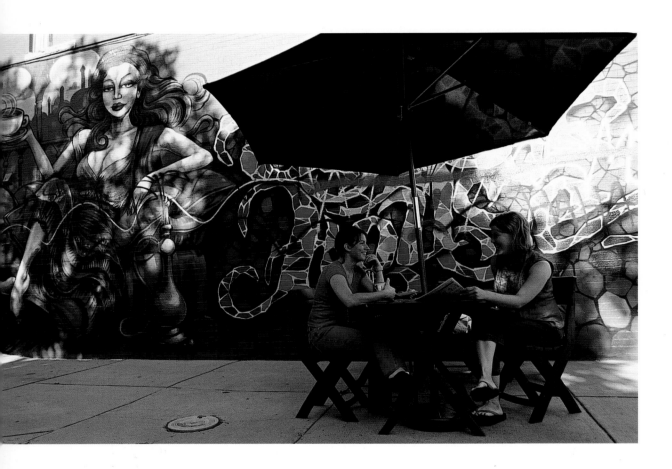

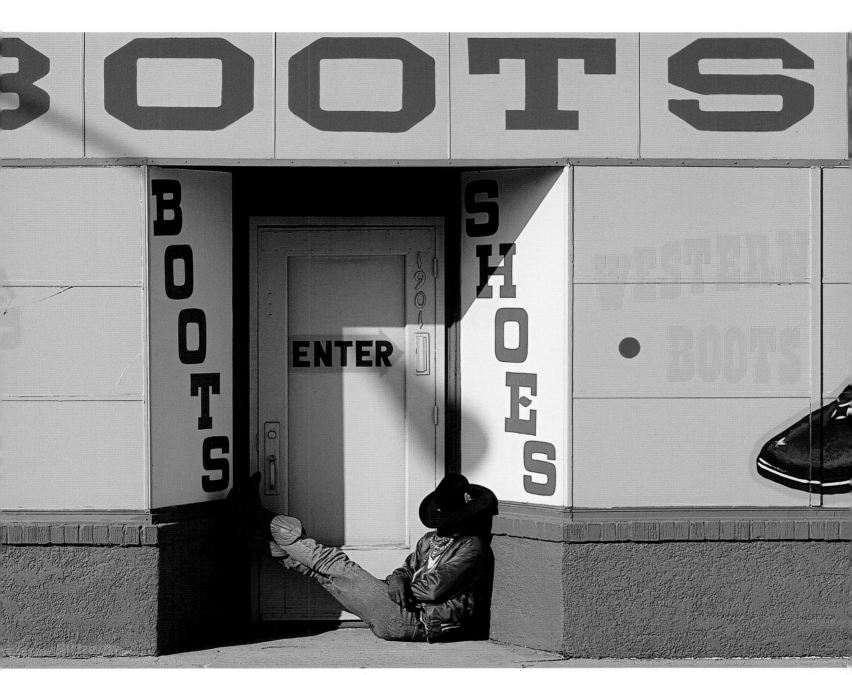

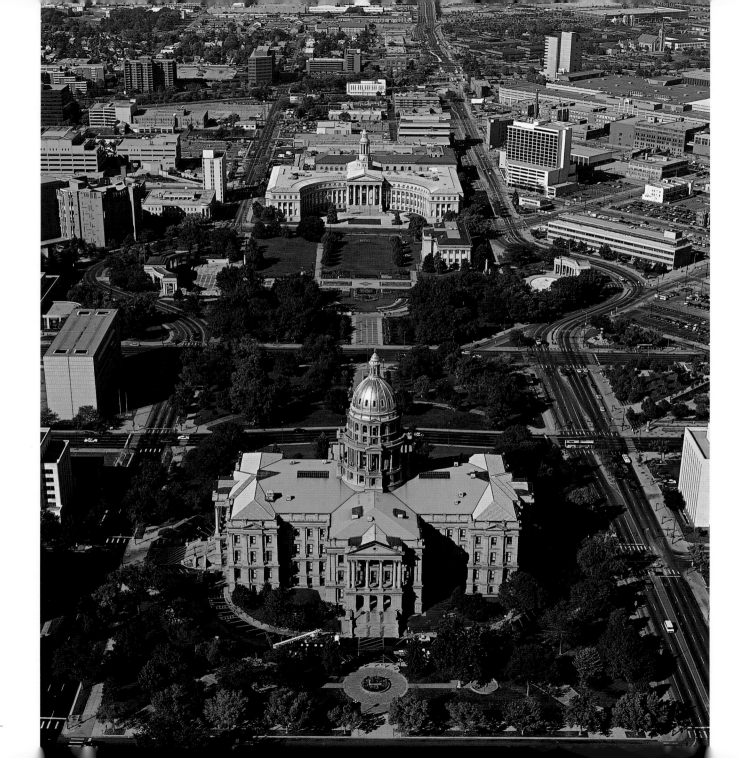

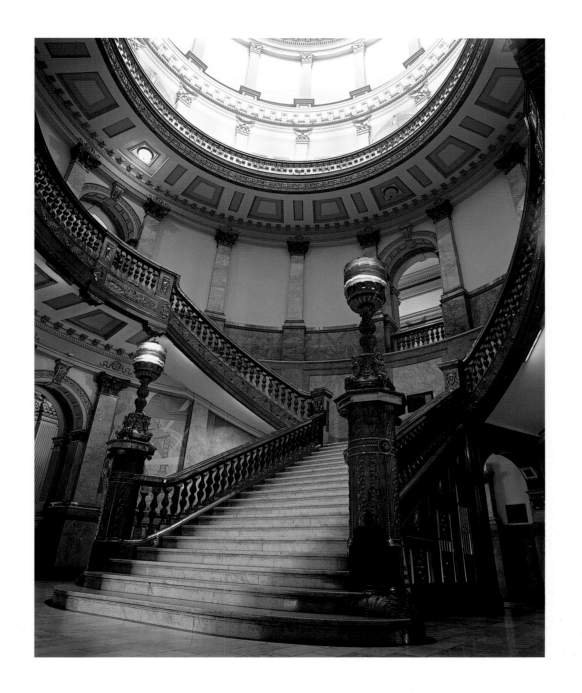

LEFT: The elegant main staircase lies beneath the eighteen-story, gold-plated rotunda of the Colorado State Capitol. The capitol's interior features rare rose marble from a quarry near Marble, Colorado.

FACING PAGE: An aerial view of the capitol, which is at a slightly higher elevation than the rest of downtown Denver.

RIGHT: A boy reaches out for one of the 1,200 butterflies inside the Butterfly Pavilion in Westminster, a facility that opened in 1995 to foster an appreciation for butterflies.

FAR RIGHT: Visitors study a *Tyrannosaurus Rex* skeleton in the hallway of the Denver Museum of Nature and Science, Denver's premier natural history museum that features an IMAX Theater and a planetarium.

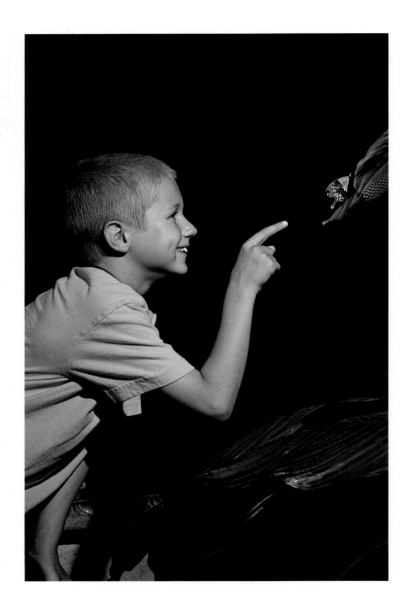

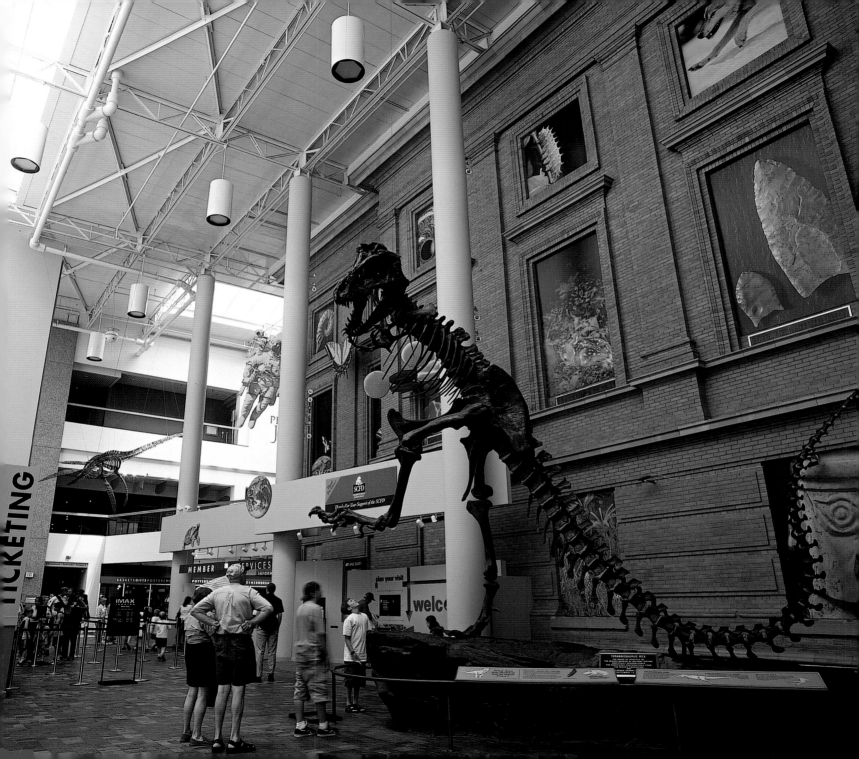

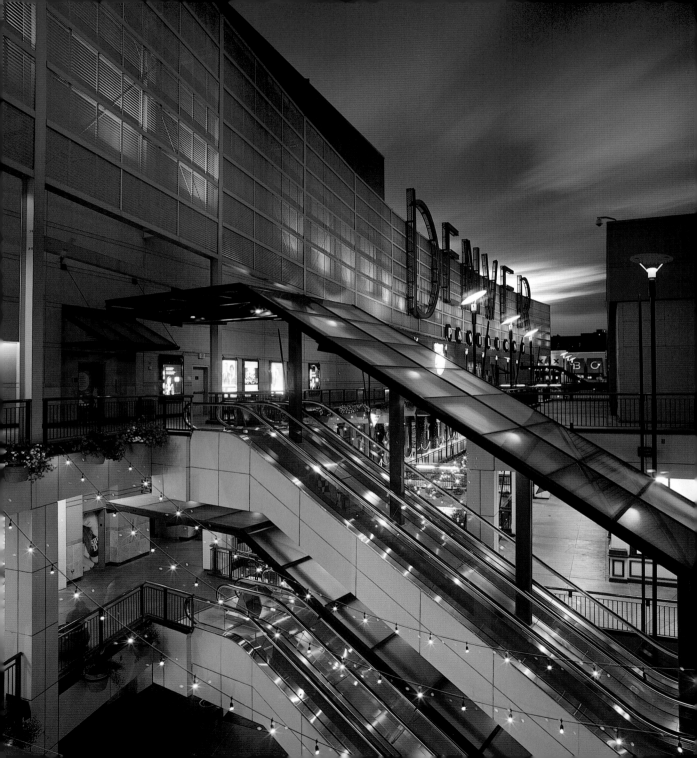

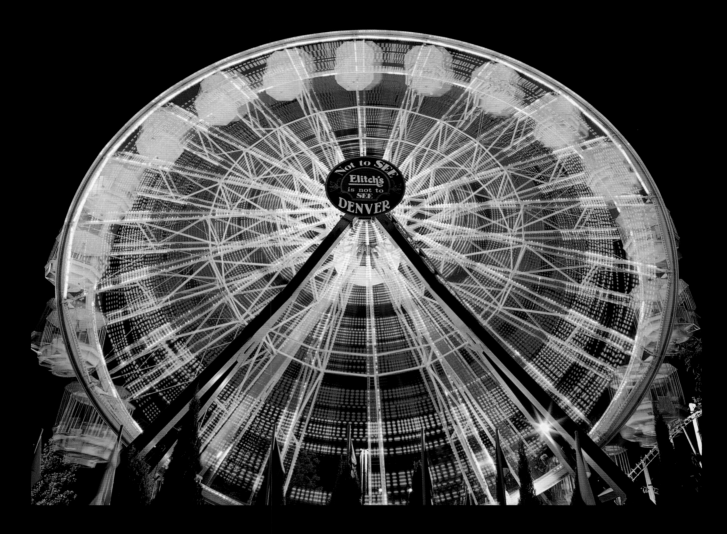

ABOVE: Lights blaze from the ferris wheel at Six Flags Elitch Gardens.

LEFT: Denver Pavilions, the Mile-High City's only shopping mall.

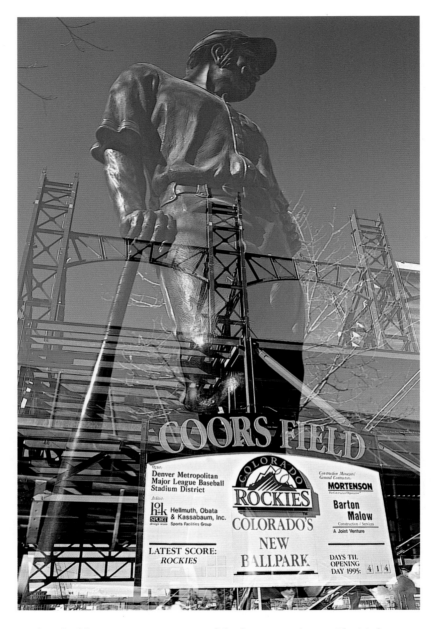

In this double exposure, an image of the bronze sculpture *The Mighty Casey*, by Mark Sundeen, is superimposed over the construction of seventy-six-acre Coors Field, Denver's first major-league baseball stadium and home of the Colorado Rockies.

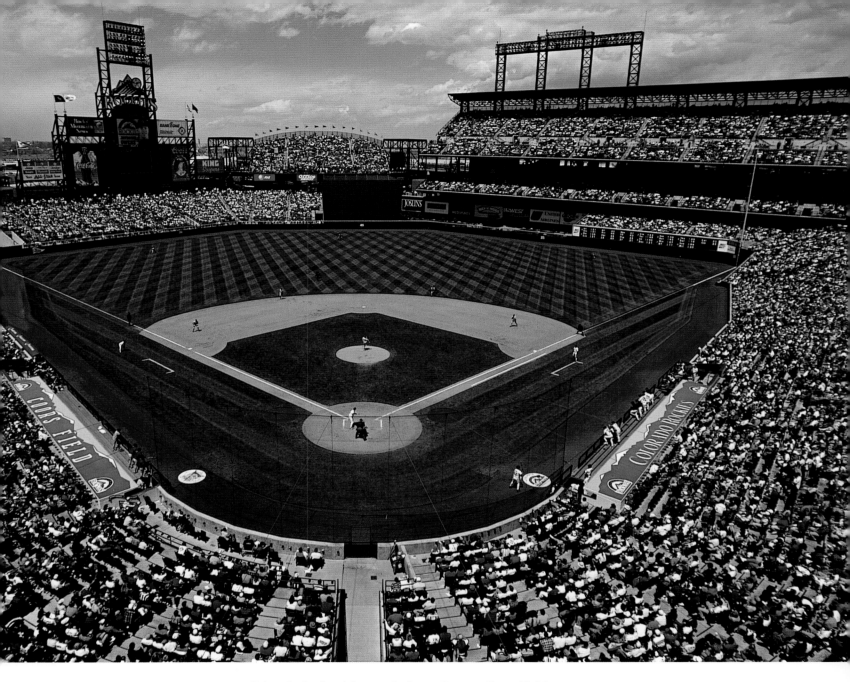

Colorado Rockies' fans pack the stadium at Coors Field.

RIGHT: Art comes in all shapes and sizes—here in a sculpture by Michael Graves entitled which sits outside the Denver Public Library.

FACING PAGE: When it was built in 1881, Denver's Union Station was the city's link to the rest of the nation.

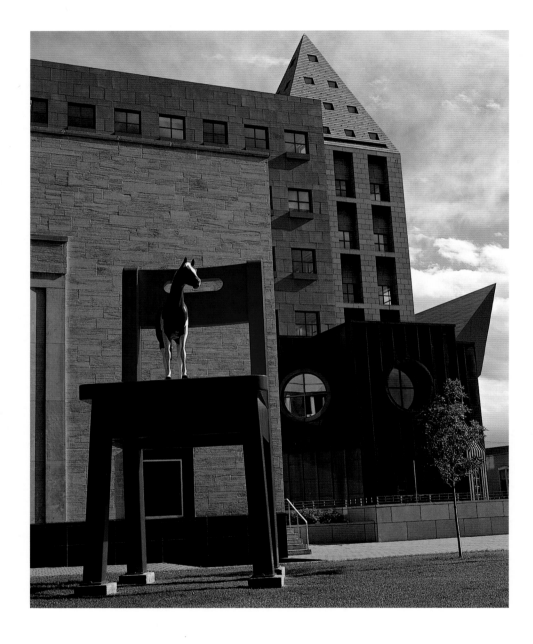

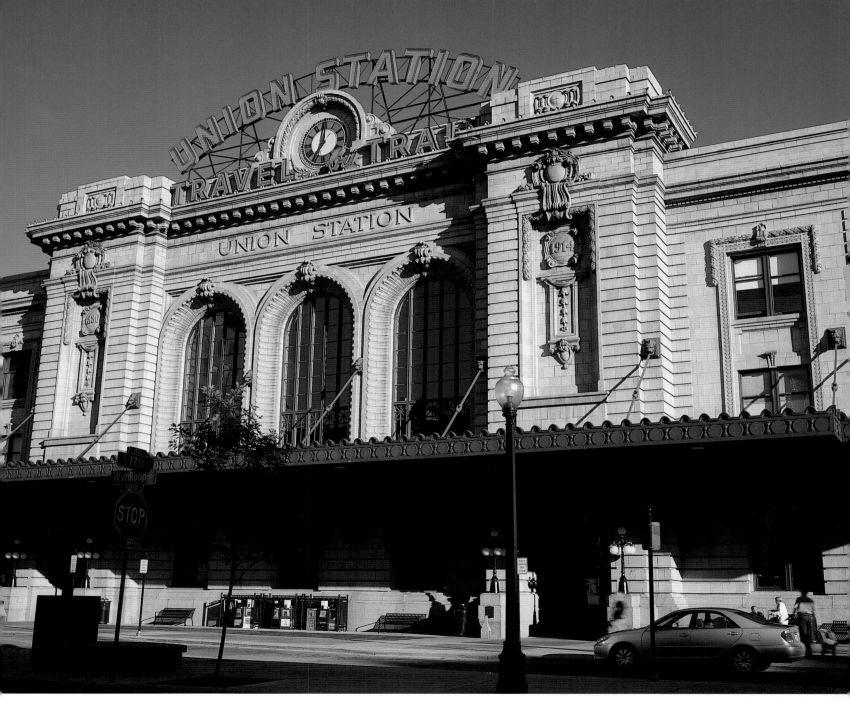

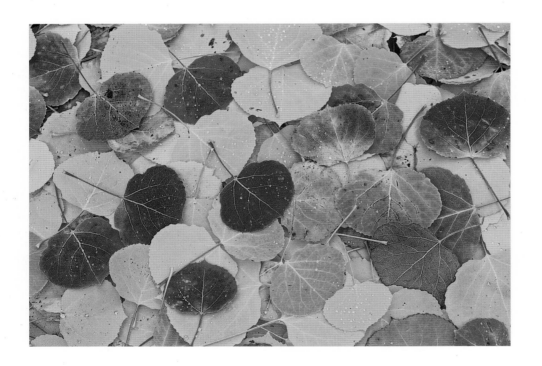

ABOVE: When aspen leaves take on an autumn blush, the Rocky Mountains blaze with colors of amber and gold.

RIGHT: The Denver Art Museum, which was founded in 1893, has one of the largest art collections in the west.

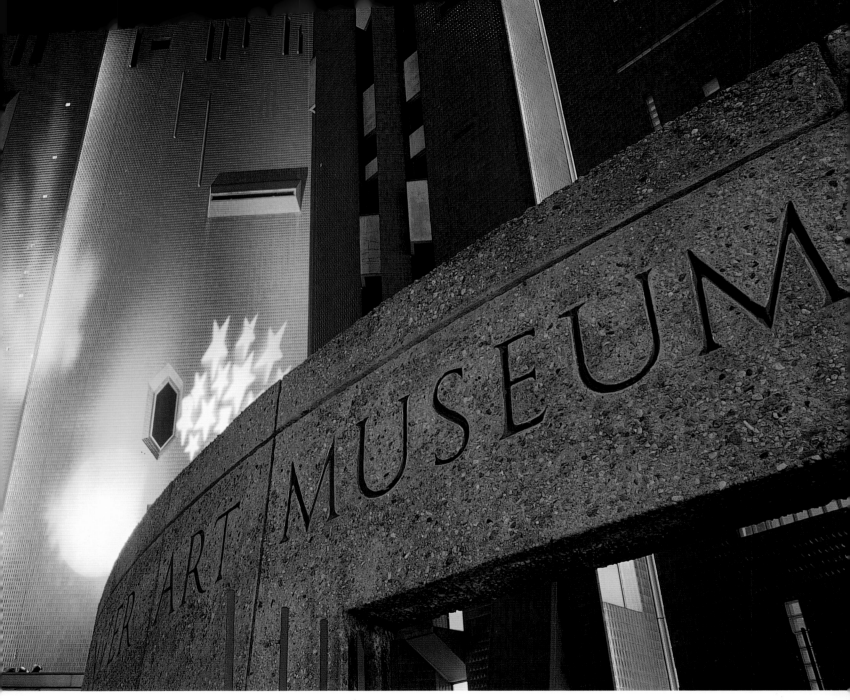

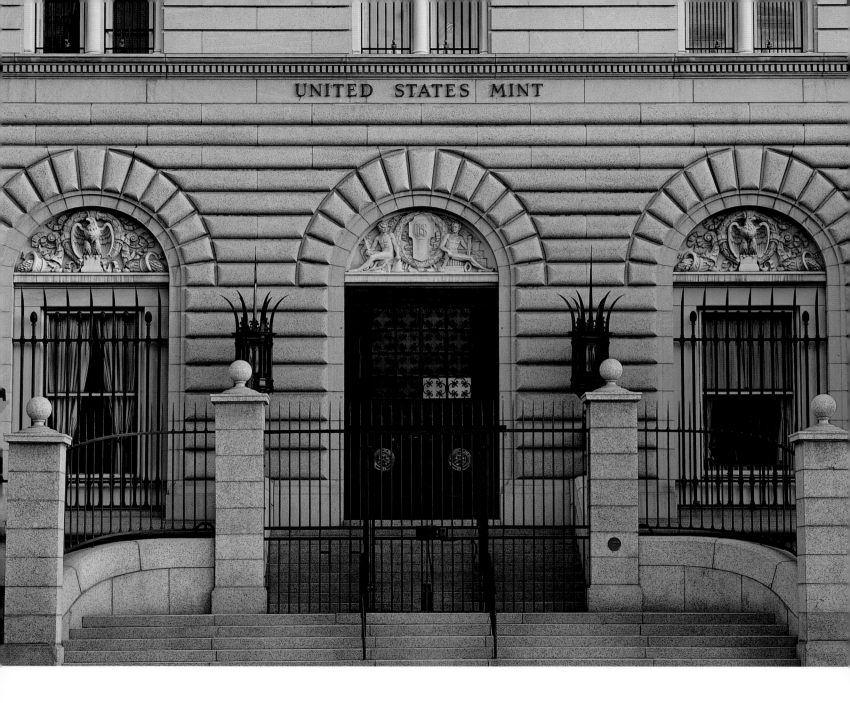

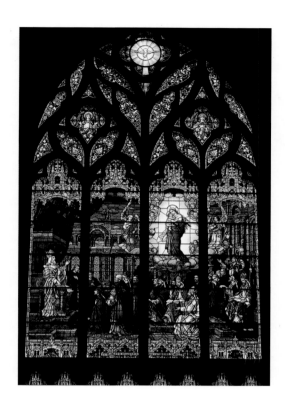

ABOVE AND RIGHT: The Cathedral of the Immaculate Conception, which began as a simple brick church built by a French missionary in 1860, now features seventy-five stained glass windows and 210-foot spires.

FACING PAGE: The United States Mint in Denver on West Colfax Street, which conducts daily tours of its facilities, produces coins of all denominations for the U.S. economy.

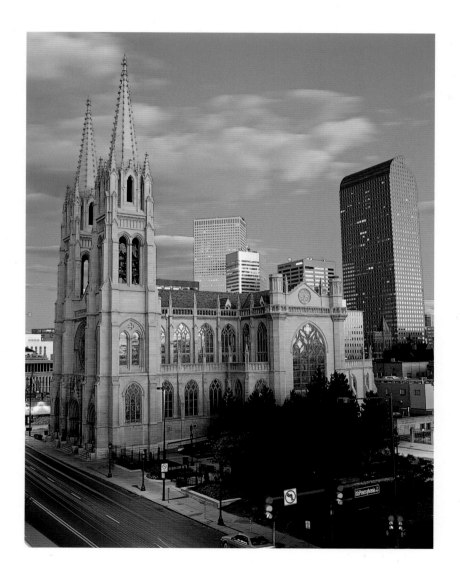

RIGHT: A dizzying skyward view of the skyscrapers at Seventh Street and Broadway Avenue.

BELOW: On a hot afternoon, children cool off in the fountain at Denver City Park.

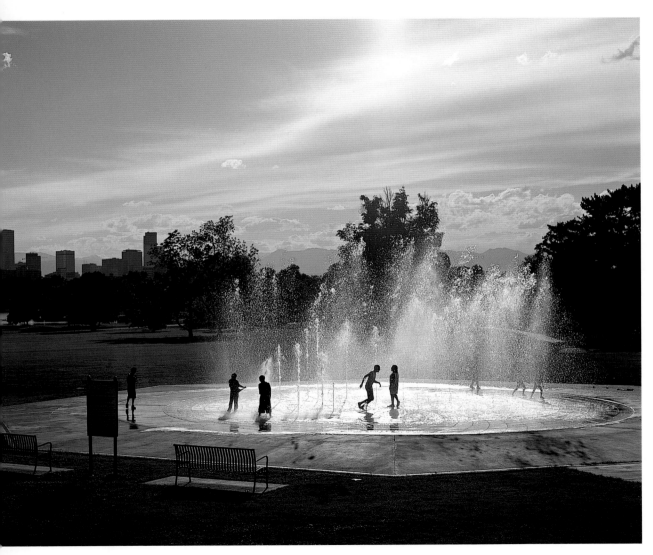

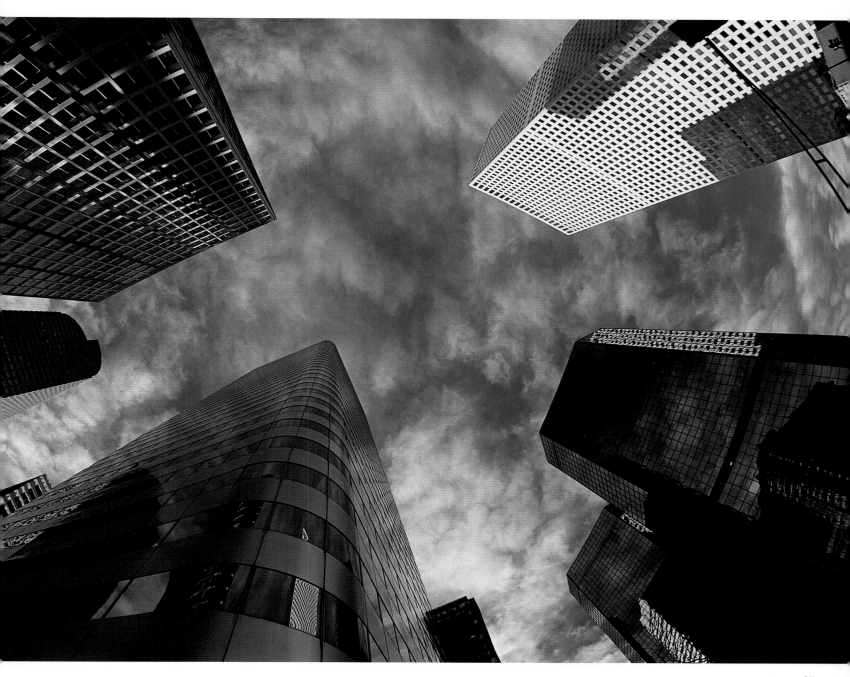

RIGHT: Rock climbers flock to the climbing walls in El Dorado State Park, between Denver and Boulder.

FAR RIGHT: Fall brings a flush of red to the sumac-covered hills in the shadow of the Flatiron Mountains near Boulder.

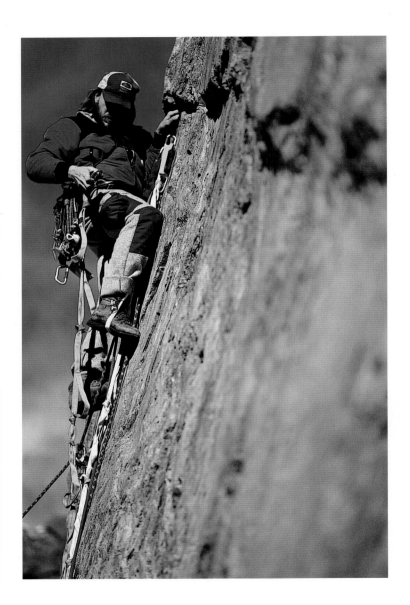

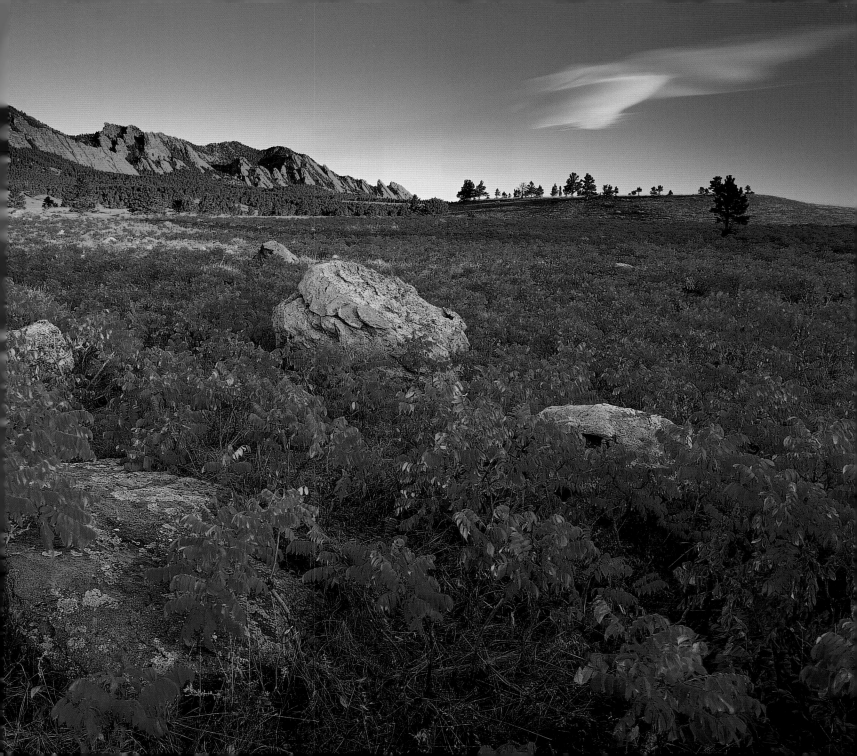

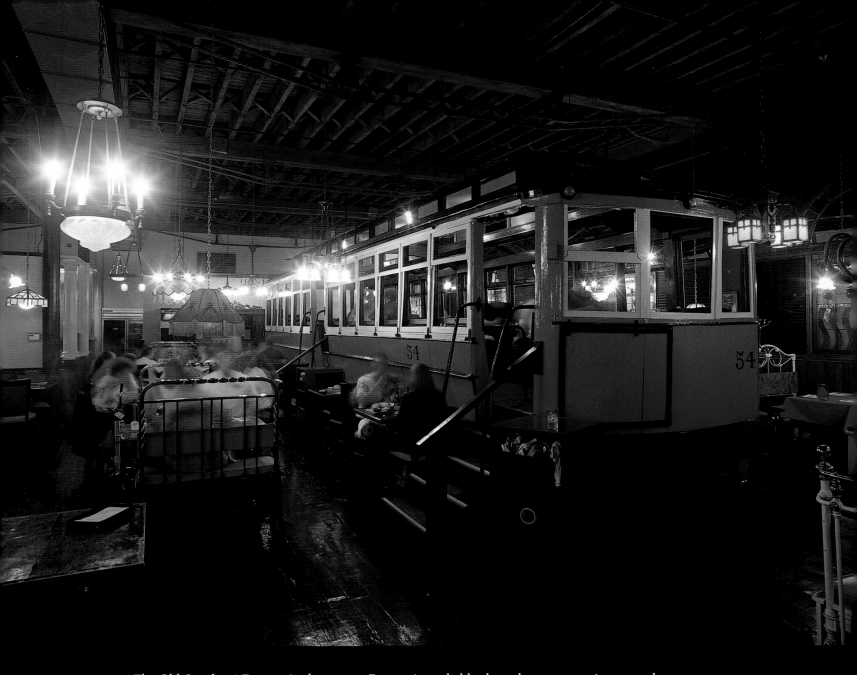

The Old Spaghetti Factory in downtown Denver is probably the only restaurant in town where you can have your Italian food served in a genuine cable car. When the original Tramway Cable Building was constructed in 1889, Denver had the longest continuous cable system in the world.

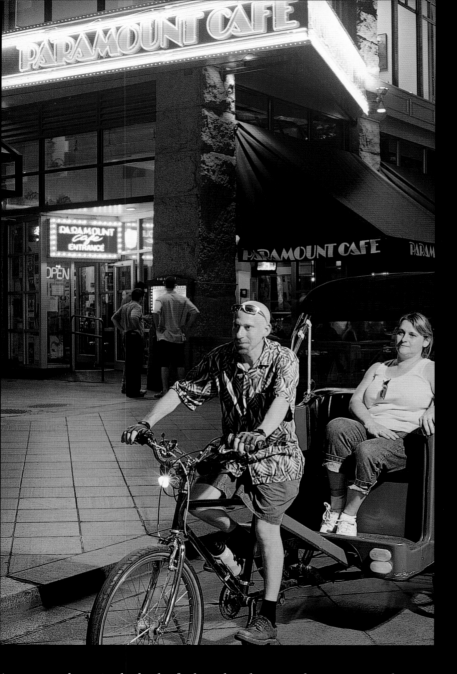

A woman relaxes in the back of a bicycle cab, a popular way to see the sights in Denver. LAURIE MOHLENKAMP

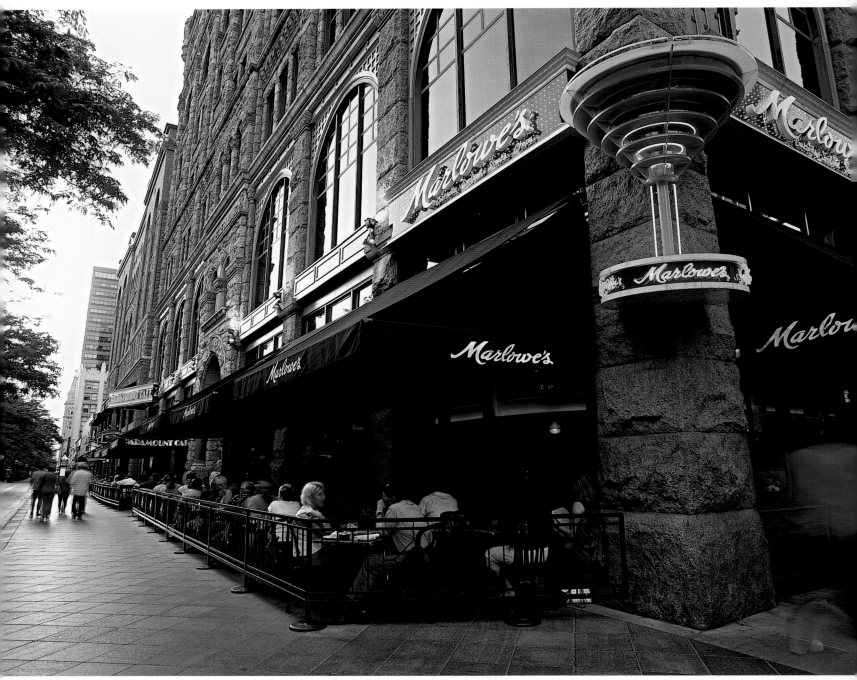

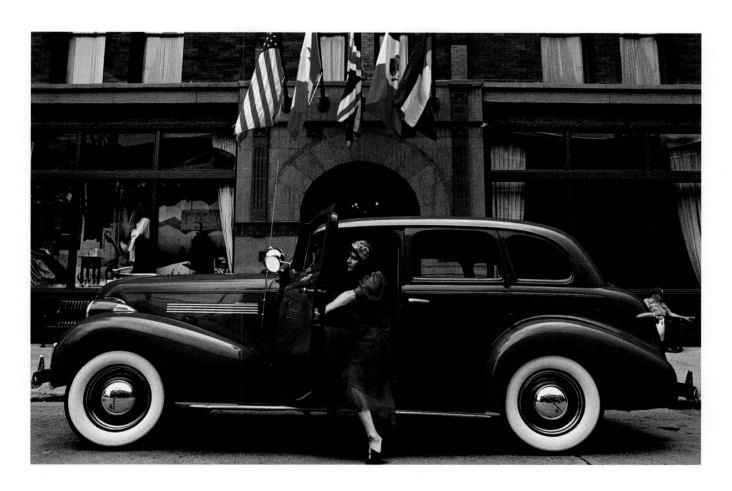

ABOVE: Just like old times, an elegant 1938 Chevrolet Sedan is parked curbside at the Oxford Hotel, built in 1891. Tucked in the trendy LoDo district of downtown Denver, the hotel is the home of the Art Deco Cruise Room bar.

FACING PAGE: Located in an old bank building, Marlowe's on the Sixteenth Street Mall is a great spot for steaks and specialty martinis.

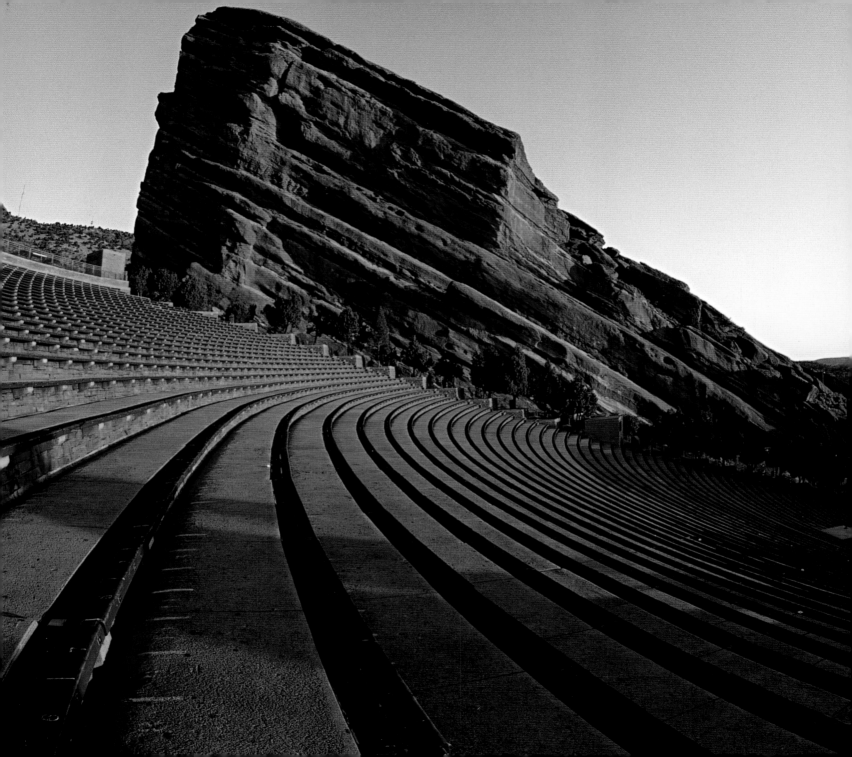

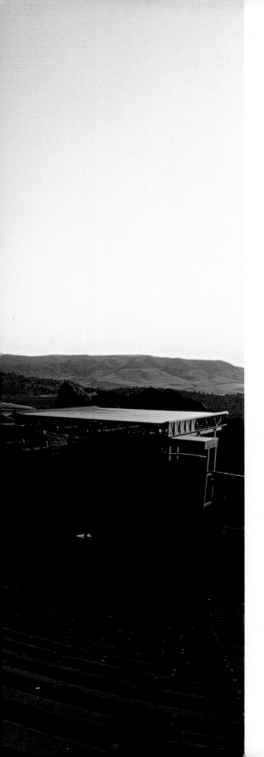

LEFT: Nestled in the foothills of the Rocky Mountains, Red Rocks Amphitheatre is a geologically formed, sandstone amphitheatre.

BELOW: Walnut Brewery, across the street from Park Meadows Mall, is a popular spot for shoppers to unwind.

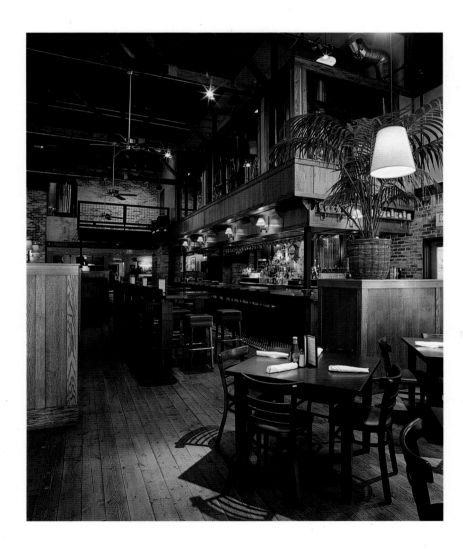

RIGHT: When it opened in 1892, the elegant interior of the Brown Palace Hotel featured an open atrium with eight floors of balconies and ornate, cast-iron railings.
LAURIE MOHLENKAMP

FAR RIGHT: As the light fades across Confluence Park, visitors enjoy walking, jogging, or just sitting in the spot where Cherry Creek and the South Platte River join.
LAURIE MOHLENKAMP

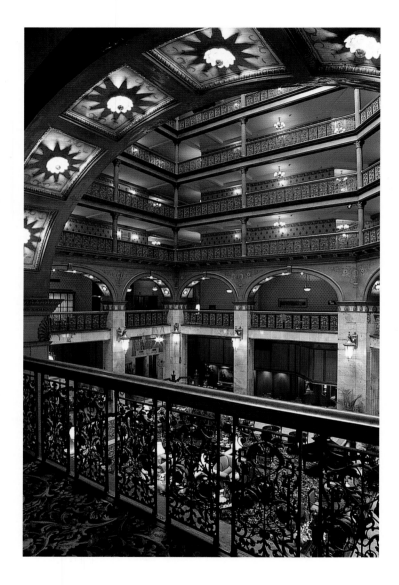

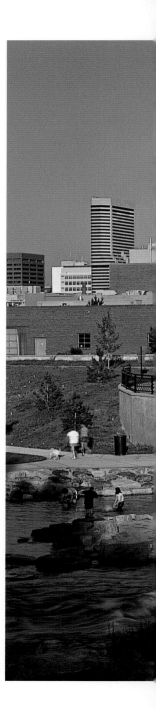

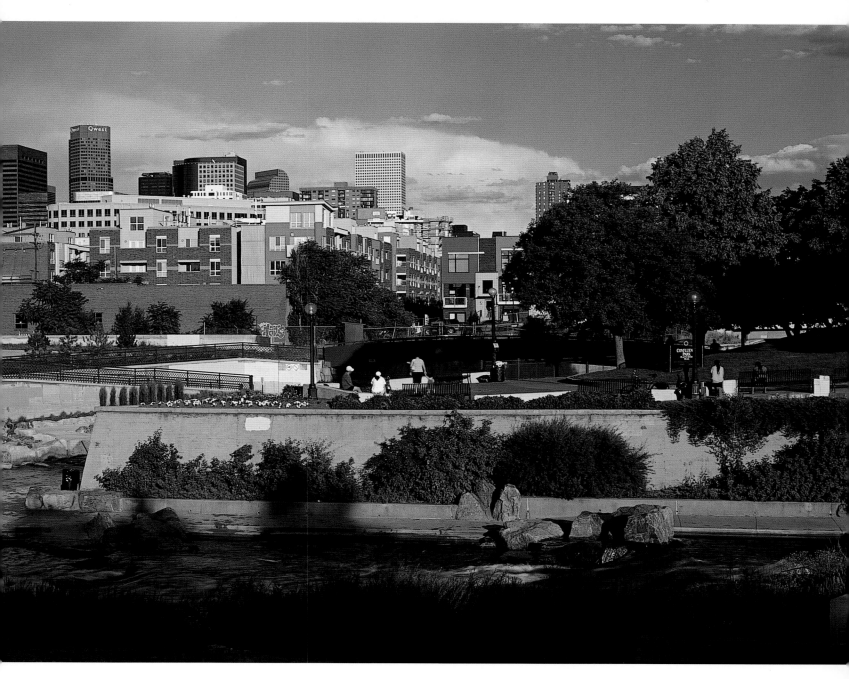

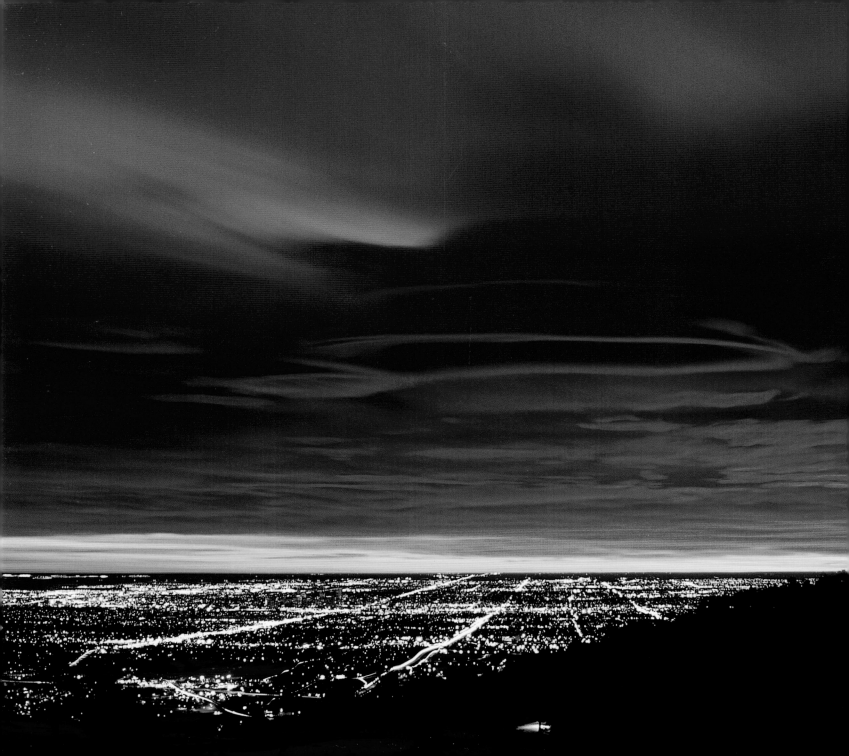

LEFT: From the top of Lookout Mountain, Denver can be seen stretching out onto the Great Plains.

BELOW: With more than 200 parks, Denver is a great place for families to enjoy the outdoors.

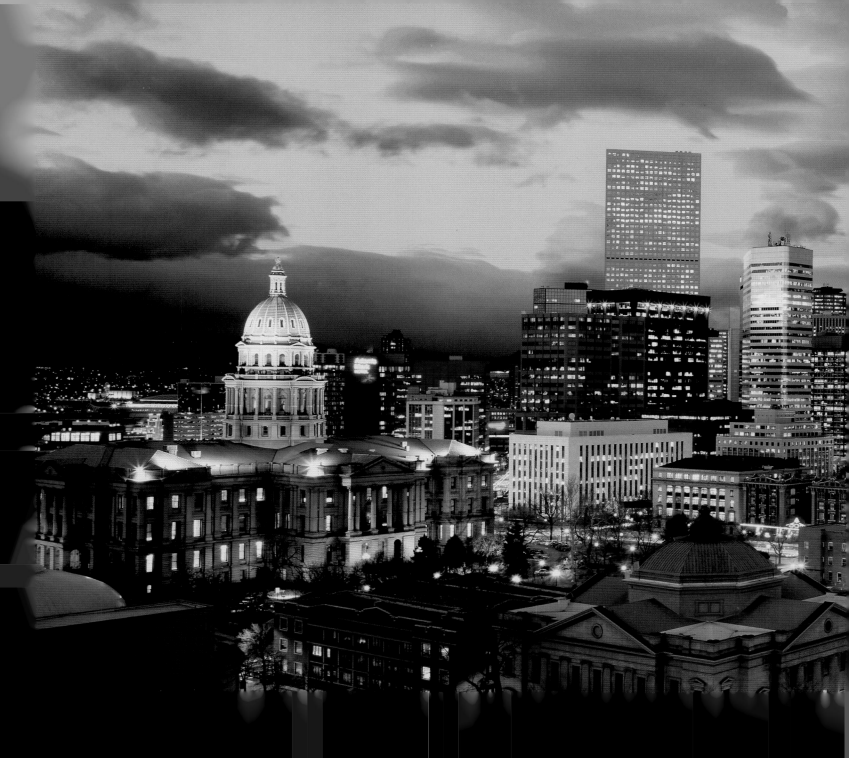

Steve Mohlenkamp is a self-taught commercial photographer based in Denver. His passion lies in transferring his own spirit of the West and its cities onto film.

"I remember going on a family vacation to the West when I was six, and spending all of my allowance on landscape and city postcards. I never sent any of them to anyone, but rather kept them for myself to look at over and over. I still remember the glowing, blazing light on the canyons and mountains in those images, and how captivating it was to me," Mohlenkamp says. "Looking back, I know now just how much of an influence that trip and those postcards really were. They beckoned me West."

Previous to operating Steve Mohlenkamp Photography in Denver for the last twenty years, Steve was a graphic designer and illustrator, a photography director at a magazine, and a corporate advertising manager.

His images have appeared in such publications as *Cowboys & Indians, Arizona Highways, Car & Driver, Sunset, Plateau Journal,* and *Road & Track,* to name a few. His commercial photography fills the needs of numerous clients, and his prints hang in many corporate and private collections.

Steve and his wife, Laurie, also an accomplished photographer, live and work together in Centennial, Colorado.

To see more from Steve Mohlenkamp Photography, please visit www.stevemohlenkamp.com.

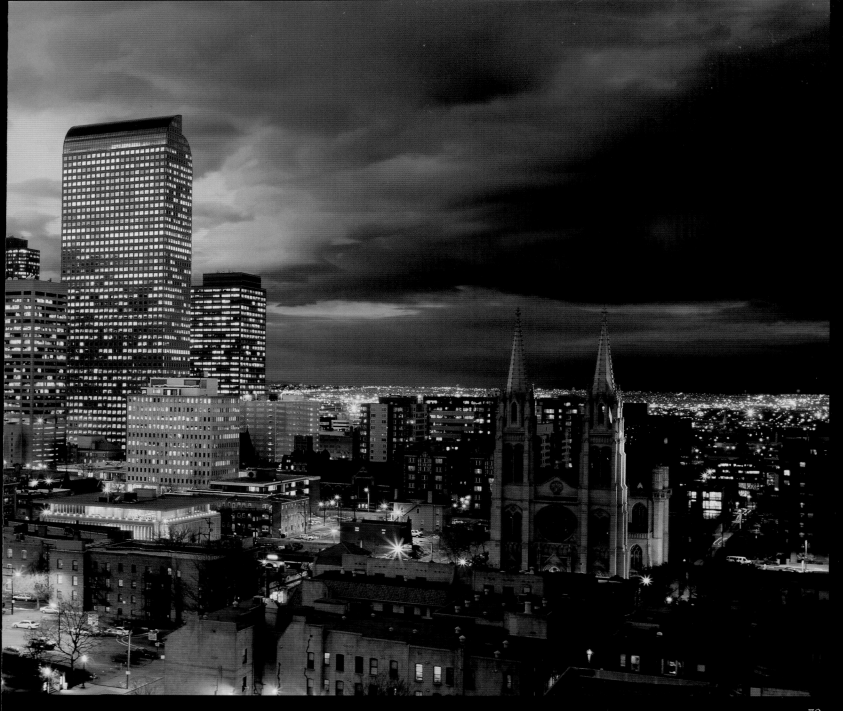